# Scottish

cons

orders

atrick

AMBERLEY

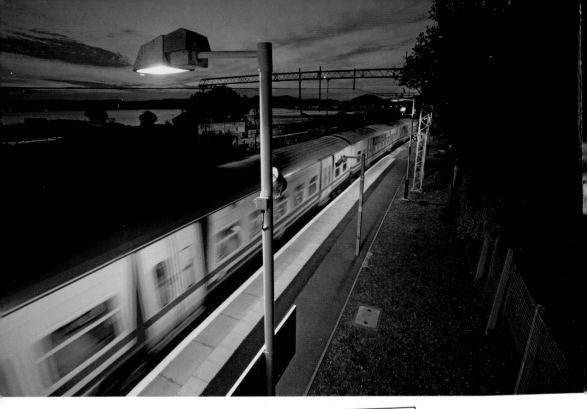

First published 2015

Amberley Publishing
The Hill, Stroud, Gloucestershire, GL5 4EP
www.amberley-books.com

Copyright © Chris Hogg and Lynn Patrick, 2015

The right of Chris Hogg and Lynn Patrick to be identified
as the Author of this work has been asserted in accordance
with the Copyrights, Designs and Patents Act 1988.

ISBN  978 1 4456 2109 8 (print)
ISBN  978 1 4456 4937 5 (ebook)

British Library Cataloguing in Publication Data.
A catalogue record for this book is available from the
British Library.

Typesetting by Amberley Publishing.
Printed in Great Britain.

# Introduction

On 27 May 1808 an Act of Parliament authorised the construction of a four-feet-gauge railway between St Marnock's depot, Kilmarnock and Troon Harbour. More sophisticated than its predecessors, the double-tracked horse-drawn railway opened on 6 July 1812. This enabled the Duke of Portland to transport coal from his pits to waiting ships and, with the addition of two coaches – *Caledonia* and *The Boat* – convey for a shilling, fare-paying passengers between the towns. Soon afterwards the Duke introduced a steam locomotive to the line built by Mr George Stephenson of Killingworth, Northumberland and the rest, as they say, is history!

Victorian Scotland rapidly became engulfed in what became known as Railway Mania. Fortunes were made and lost as speculators formed companies, applying for Acts of Parliament to authorise their railways from a government with a laissez-faire attitude. As a consequence regulation was non-existent and the iron roads, complete with tunnels, bridges, viaducts and stations, marched across the country, while the companies vied with each other for valuable goods and passenger traffic.

The coming of the railway had an immediate effect on communities, as at North Berwick and Milngavie, creating opportunities for huge investment and development, or as in Gretna's case, giving rise to protest by residents and the church. Others developed a fondness for their railway: the Edinburgh and Dalkeith Railway was nicknamed 'Innocent', recalling its golden age of horse-drawn, leisurely travel. Unfortunately the railway also held the power to destroy communities, as in Leith where inscriptions above a mass grave at Rosebank Cemetery testify to the horror of the Quintinshill disaster.

The railway enabled travel for work and pleasure, opening up the country for the price of a ticket. It spawned the word 'commuter' as every morning, trains spewed out workers onto the station platforms of ever-expanding towns and cities. It transported urgent goods to shops, factories and shipyards, and excited families to holiday resorts around the country or 'Doon the Watter' on railway steamers. City Station, and some of the larger town, stations had stylish and elegant railway hotels attached, catering for a 'fashionable' clientele. Meanwhile Glasgow was rapidly becoming a world locomotive building centre, with five railway works in the city and another down the road in Kilmarnock.

In order to build both stations and infrastructure with a style and grandeur reflecting their own self-confidence, the companies employed a new breed of engineer and architect, some of whom were destined for greatness. John Miller, the 'Scottish Brunel', was responsible for almost 40 per cent of the network by 1840, and plaques on a number of railway buildings testify to his brilliance. Sir William Arrol, the great bridge builder to the world, is commemorated on the first British polymer £5 note.

Other reputations were somewhat tarnished. The Solway Viaduct, whose sole purpose in the years up to its demolition was to allow pedestrian access to English public houses for Scots on 'dry' Sundays, was engineered by Sir James Brunlees. So revered was Brunlees that he was called to give independent advice during the enquiry into the Tay Bridge Disaster. Unfortunately his viaduct suffered a similar fate a couple of years later when forty-five of its piers collapsed due to ice flows. Fortunately for Brunlees the track was clear at the time.

Some railway structures have figured in moments of history. In October 1939 passengers on trains crossing the Forth Bridge watched flumes of water from exploding bombs – some as high as the bridge itself – erupt from the Forth as Luftwaffe bombers on their first British raid of the Second World War attacked Royal Navy warships anchored in the Firth. For reasons known only to the Ministry of Information a contemporary documentary film, *Squadron 992*, directed by Harry Watt for the GPO Film Unit, skewed the facts, asserting that the bridge was the target.

As with many other railway locations in Scotland, the Forth Bridge has regularly featured in print and on film, most notably in Alfred Hitchcock's and Ralph Thomas's film versions of *The Thirty-nine Steps*. Yet close-ups of Hannay hiding from the police in Hitchcock's 1935 adaption were shot on a recreation of the bridge in Stapleford, Hertfordshire!

Though a number of railways had closed well before the 1960s, notably the light railways – low-cost lines built in rural areas – Dr Richard Beeching's 1963 report *The Reshaping of the Railways* dramatically reduced the network. Despite vociferous protest and appeals to parliament, railways were closed, their tracks lifted and buildings and infrastructure abandoned, demolished or repurposed and many towns and villages were left devoid of a rail link.

This book celebrates the heritage and legacy of Scotland's Railways in the Central Belt to the Borders, that which was lost and that which has survived, while casting a brief eye over future developments. After the obvious inclusions the others are our own personal choice, an emotional response to the many sites we have visited during our working lives. All are unique and many are recognised with listed status and are examples of superb design, architecture and engineering of which Scotland can justifiably be proud. Please enjoy the book.

The following railway companies and lines occur regularly in this book and have been abbreviated to their initials, which is usual railway parlance:

The Caledonian Railway (CR)
The Glasgow and South Western Railway (G&SWR)
The Edinburgh and Glasgow Railway (E&G)
The North British Railway (NBR)
East Coast Main Line (ECML)
West Coast Main Line (WCML)

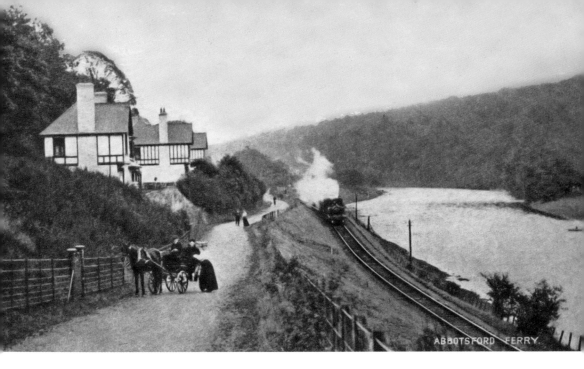

## Abbotsford Ferry Station

Originally known as Boldside and Abbotsford Ferry, it was the epitome of the rural lowland Scottish station. Set alongside the picturesque wooded northern banks of the River Tweed it was a mere ferry ride – a small rowing boat linked by elevated guide lines – from Abbotsford House, the former home of novelist and poet Sir Walter Scott. The Scott family, finding tourists an inconvenience, were provided with their own personal waiting room. Abbotsford Ferry was an intermediate station on the five-mile branch built by the Selkirk and Galashiels Railway to service the textile industry and opened in April 1856. The station was rebuilt as a more substantial structure a few yards to the north-east around 1880 and continued until closure in January 1931. The line remained open until 1966 and today is a public bridleway.

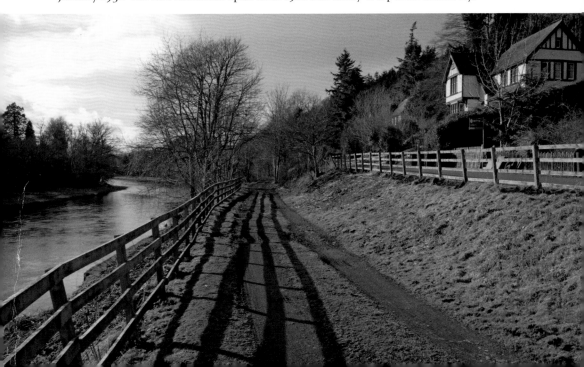

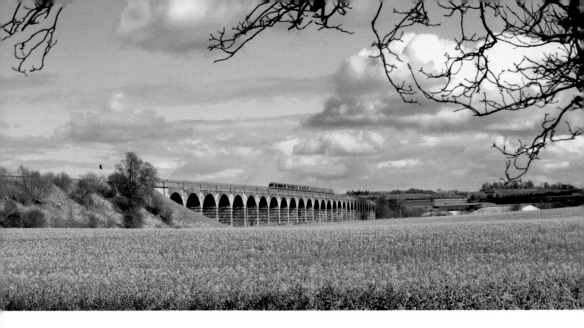

## Almond Valley Viaduct

The Almond Valley or Ratho Viaduct is a spectacular category A-listed structure on the E&G, Scotland's first high-speed railway. The viaduct, conceived, designed and built by John Miller, then aged twenty, opened to traffic on 18 February 1842. The line was said to be English-financed, as 90 per cent of the shareholders were English, and Scottish-managed, with nine of the eleven directors Scottish. The viaduct is in two sections, separated by an embankment some 437 yards in length. The western section comprises seven arches while the eastern section, which crosses the River Almond, is made up of thirty-six arches. There has been much strengthening to the viaduct in recent years using concrete to infill the hollow piers and arches, and old rails to brace the spandrels.

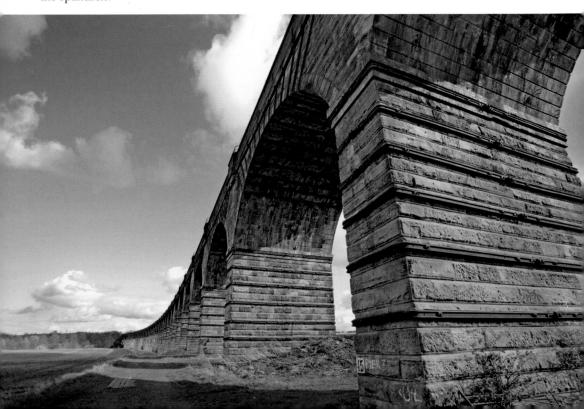

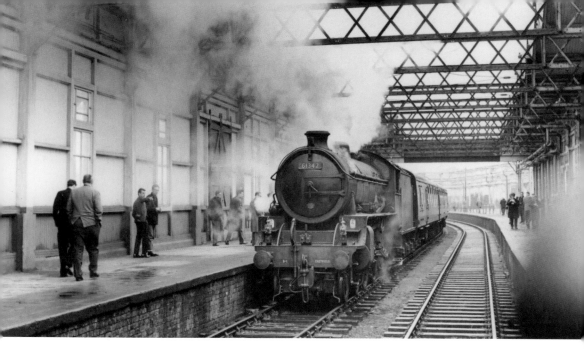

### Ardrossan

Railways were important to Ardrossan. Through the years the town has had six railway stations. Ardrossan Town, South Beach and Harbour Stations still remain, while Winton Pier, Montgomerie Street and Montgomerie Pier have gone. In late Victorian times Ardrossan's deep-water port experienced considerable traffic as more than eighty-four pits sent record amounts of Lanarkshire coal by rail to the harbour for export. In a bitter battle for passengers on ferry sailings to Belfast, the Isle of Man and Arran, the CR ran its Glasgow Central boat trains to Montgomerie Pier, while the G&SWR ran the fastest boat train in Britain, travelling from St Enoch for Winton Pier at an average speed of 58.2 mph. How different it is today – the harbour is now a marina and the boat train arrives at a bleak platform with a dreary shelter.

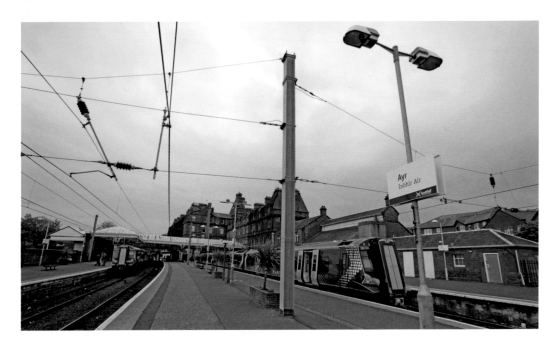

### Ayr Station and Hotel

Ayr Station and hotel were built by G&SWR after the success of St Enoch Station and its hotel. It is the third station to carry the name, replacing earlier stations by the Glasgow, Paisley, Kilmarnock & Ayr and the Ayr & Dalmellington Railways. The current station opened in January 1886, complete with the red sandstone, four-storeyed Station Hotel, designed in French Renaissance style and finished with pavilion roofs. The station, with offices situated on the ground floor, comprises two through platforms and two bay platforms. Today the canopy, which still covers parts of all the platforms, has been cut back while the waiting area has been glazed to protect from the elements. Unfortunately the hotel, sold by British Transport Hotels (BTH) in 1951, is now closed. Surrounded by security barriers it is a pitiful sight.

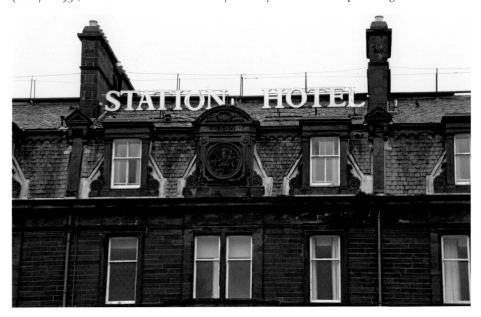

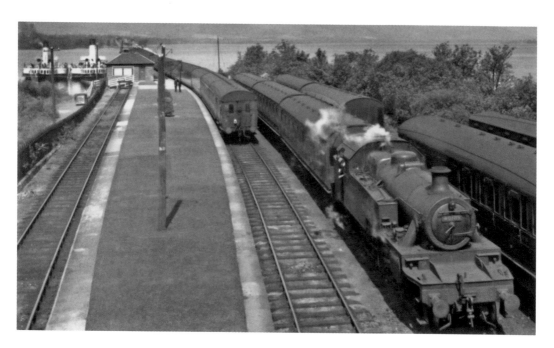

## Balloch Pier Station

Idyllically situated on the southern shore of Loch Lomond, Balloch Pier Station closed in September 1986 as a result of the Strathclyde Rail Review. Opened as Balloch Wharf Station by the Caledonian and Dumbarton Railway in July 1850 and later controlled jointly by the CR and NBR, it served the steamers berthed on Loch Lomond. The steamers were an important means of communication to the more remote communities of the loch, carrying passengers, mail, goods and livestock. The loch, a link in the route from Glasgow to Inverness, had become a fashionable destination after Dorothy Wordsworth wrote of its glories, and a later cruise by Victoria and Albert only increased its popularity. Commuter traffic was vital business. Passengers disembarking at the pier would find both CR and NBR trains waiting to speed them on the forty-minute journey into Glasgow.

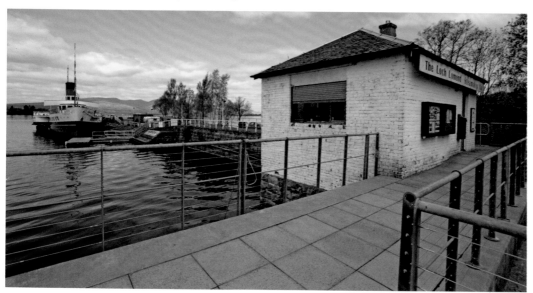

## Ballochmyle Viaduct

Only by standing in the gorge of the Water of Ayr – its sylvan exuberance much admired by Victorian tourists – can the size and grandeur of Ballochmyle Viaduct near Mauchline be fully appreciated. The central arch span, measuring 185 feet, was at the time of construction the largest masonry arch in the world, and at 177 feet in height is still the highest in Britain. Designed by John Miller for the Glasgow, Paisley, Kilmarnock and Ayr Railway it was completed in 1848. The viaduct even featured in the 1996 film *Mission Impossible*, as Tom Cruise clung to the roof of a TGV! The seven-span category A-listed structure was designated as a National Civil Engineering Landmark by the Institute of Civil Engineers in 2014, after being upgraded to handle heavy coal traffic.

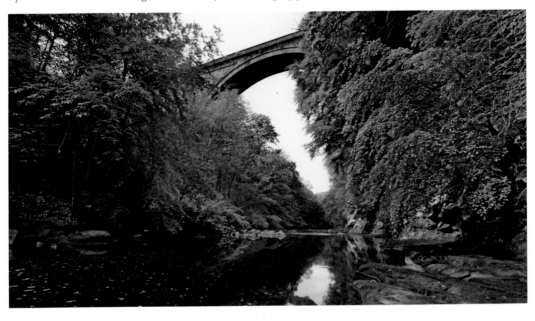

### Barrhill Station

Follow a steep, twisting road up the hill from Barrhill village for a mile or so to reach Barrhill Station. Here, hares sit on the platforms watching the trains arrive and depart. The station opened in 1877 as part of the Girvan and Portpatrick Junction Railway and, since the Beeching cuts, its catchment area has grown to well over twenty miles. On the down platform sits a small signal box brought from Portpatrick after the original was destroyed by fire. The box operates the station passing loop but the tablet instruments and the block bells are in the main building, allowing one person to act as signaller and stationmaster. The line between Girvan and Stranraer is one of the last on the rail network to use Electric Token Block working, a method of signalling a single line route.

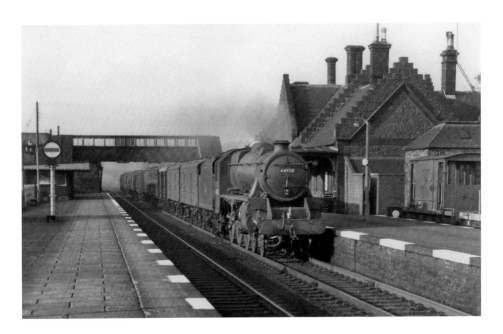

### Beattock Station

In John Buchan's 1915 novel *The Thirty-nine Steps*, hero Richard Hannay walks from Moffat to Beattock to catch the night express to London. Beattock Station was opened by the CR on 10 September 1847. Located on the Caledonian Main Line the station shed was home to a fleet of banking engines dedicated to pushing goods and passenger traffic up and over Beattock Summit, the highest point on the WCML, ten miles to the north. Between 1881 and 1964 the station was the junction to a two-mile branch line, which serviced the town of Moffat. Beattock Station closed in 1972 as a result of the WCML electrification scheme. Today, remains of the station are still visible and a vigorous reopening campaign continues to gain momentum.

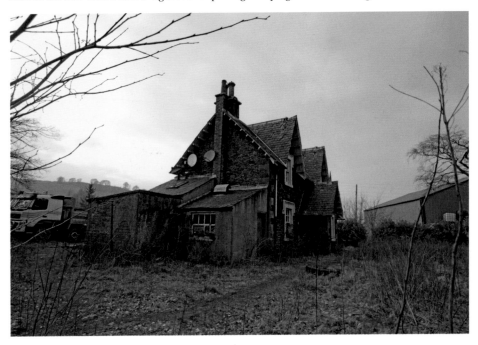

### Beattock Summit

No other climb to a summit has been better described than in the 1936 GPO Film Unit's *Night Mail*. The words of W. H. Auden's poem, written specifically for this film, are at the heart of a perfect eulogy to Beattock Summit in pictures, words and music. The summit itself is less poetic. It is the highest point on the WCML, at 1,016 feet above sea level. The line, constructed by a rather reticent CR, opened on 15 February 1848. The CR chairman had suggested that, due to public fears of the railway climbing to such great heights, an alternative route should be found. As it was, most northbound steam-hauled trains required banking assistance from Beattock Station up the 10-mile incline to the summit. Today's powerful diesel and electric locomotives are capable of ascending the gradient independently.

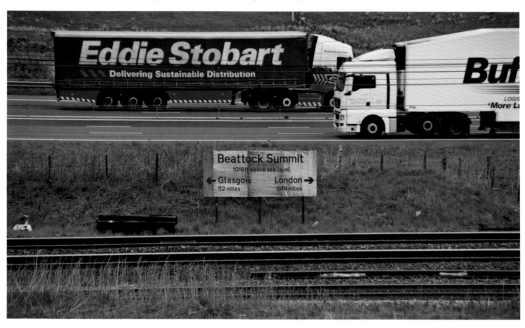

### The Border

There is an excitement in crossing the border and arriving in another country, and there are two points where the railways still cross the border between England and Scotland. Gone are the days when the border was represented by flags and barriers. Now the lineside border markers bearing national symbols flash by faster than the eye can take in. On the ground it is a bit easier to spot where the train crosses from one country to another. The WCML crosses at the River Sark just before Gretna, the ECML close to Lamberton, three miles to the north of Berwick on Tweed – both unassuming locations. The ECML crosses the River Tweed at Berwick over the dramatic Royal Border Bridge. The river constitutes the border for most of its length, but ironically not at this bridge.

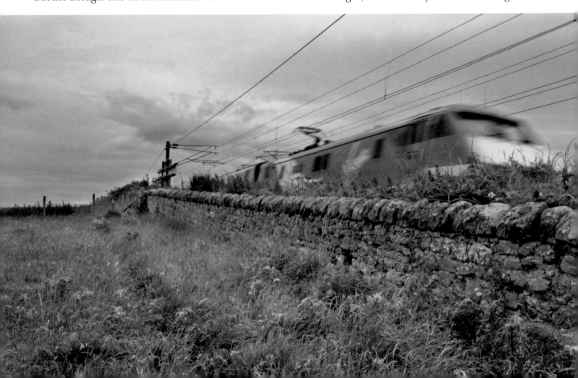

### The Borders Railway

The Borders Railway is the longest new domestic railway to be opened in the UK for 100 years. The campaign to reopen a part of the former Waverley Route was realised on 6 November 2012 when the Scottish Government's Transport Minister Keith Brown announced that almost thirty-one miles of the route between Newcraighall and Tweedbank would be reinstated for rail traffic. Construction costs were held at £350 million, influenced by the government's decision to slash provision of a double track from fifteen to nine and a half miles, despite predictions by experts that this would hamper smooth running of the railway. In all, nine stations were either built or reopened on the route. Opened in September 2015, the line has been reinstated with no crossings, and roads have either been rerouted or new over-bridges built.

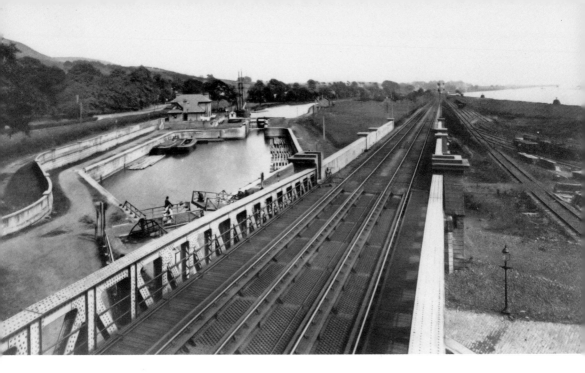

## Bowling Station and Basin

The Caledonian and Dumbarton Railway opened Bowling Station on 15 July 1850, the southern terminus of an L-shaped, eight-and-a-half-mile line connecting Bowling, Dumbarton and Balloch. The railway linked Loch Lomond and Glasgow via the Clyde's steamers and barges on the Forth and Clyde Canal. Frisky Wharf was constructed at Bowling to process the passenger and freight traffic and the canal basin was expanded. The line was extended west by the NBR to Helensburgh and eastwards to Glasgow. Meanwhile in 1896 the CR opened its own route between Glasgow and Balloch, which crossed the NBR line at Bowling Basin. This line closed in 1951 and is now a public footpath. Today Bowling Station is famous as the site of Terrence Cuneo's 1965 painting *Blue Train at Bowling Harbour* and is part of the North Clyde Line.

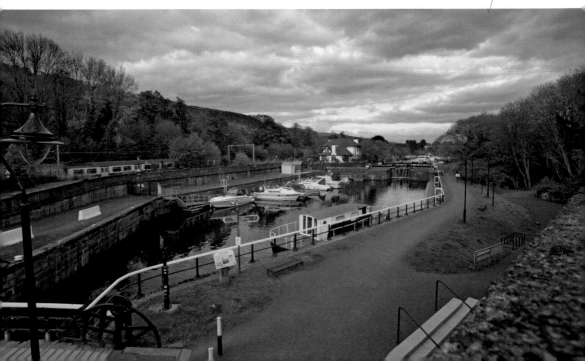

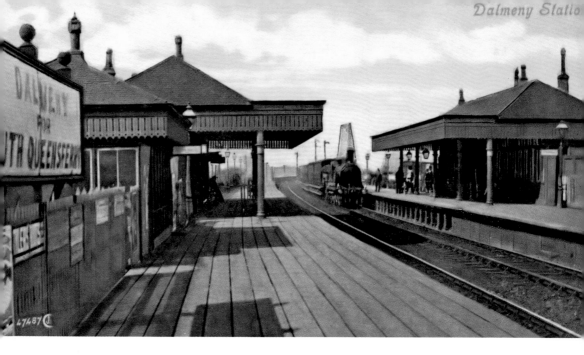

### Dalmeny

The north end of the down platform at Dalmeny Station is the ideal place for a driver's-eye view of the Forth Bridge, and with good visibility and a vivid imagination, headlights of southbound trains can be spotted far beyond the bridge's receding throat of red girders. The NBR opened the station on 5 March 1890, the same day as the bridge, to serve the communities of Dalmeny and South Queensferry. It replaced an earlier station on the NBR South Queensferry branch, which opened on 1 June 1868. The branch, today a footpath, was built to deliver passengers and goods to the company's ferries on the Forth crossing. It was further extended to a new railway pier at Port Edgar on 1 October 1878, which today is fenced off and in a dilapidated state.

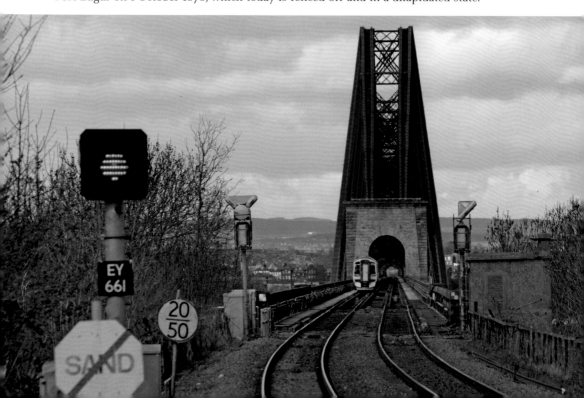

## Deadwater Station

'The Lilliputian station with a narrow platform and an outlook that is wild, solitary and beautiful.' So Deadwater Station was described by A. G. Bradley in 1908 in *The Romance of Northumberland*. Here the Border Counties Railway crossed the border, branching off the Waverley Route at Riccarton Junction and on via Deadwater to Hexham and Newcastle upon Tyne. Opened on 1 January 1862 the station lies just inside Northumberland. Travelling south, the railway was the actual border for over 250 yards, until it turned west across the track at the northern end of the station. This point was denoted by a border sign, now in the care of the National Railway Museum at York. After the Second World War a stationmistress was appointed to manage the station, which closed along with the unprofitable line on 13 October 1956.

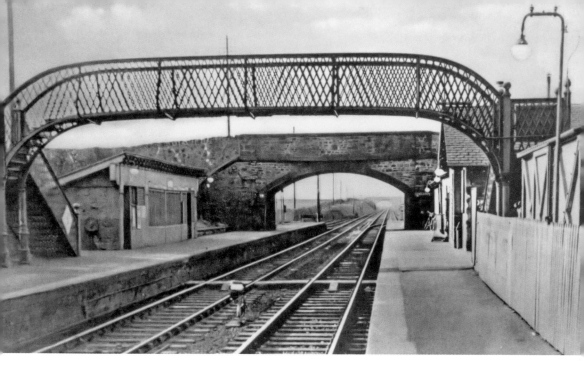

## Drem Station

The NBR constructed Drem as an intermediate station on the Edinburgh to Berwick on Tweed Railway, opening on 22 June 1846. The station's status improved in August 1849 when the branch to North Berwick opened. Until the end of steam, passengers would change at Drem for the branch but the advent of Diesel Multiple Units saw trains running straight through to Edinburgh. In 1985 British Rail, without seeking permission, started to demolish the category B-listed, unspoilt example of a wayside station, starting with the waiting facilities on the down platform. These were quickly rebuilt as an exact replica when the authorities stepped in. Today the lattice footbridge has been replaced with an individually designed structure and local trains continue to call as ECML traffic thunders through.

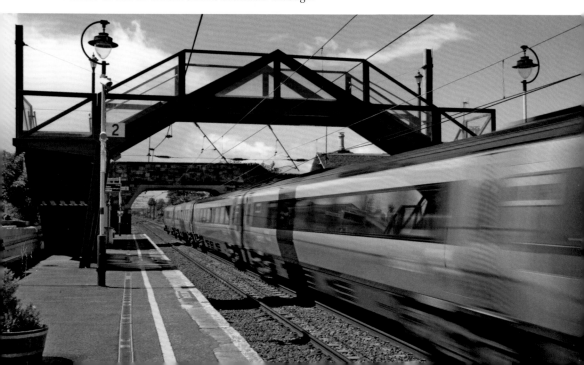

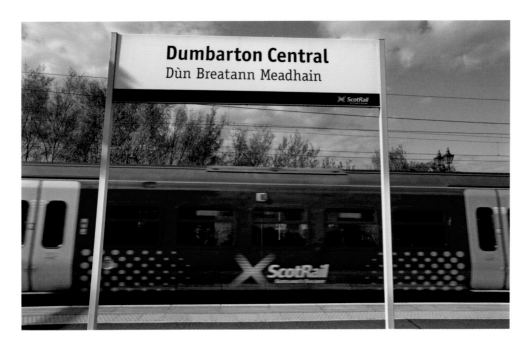

### Dumbarton Central Station

Due to an overall lack of industry, railway development came late to the north bank of the Clyde, the exception being the Leven Valley with its printing, bleaching and dyeing works. As a consequence it wasn't until July 1850 that Dumbarton Central Station opened as part of the Caledonian and Dumbartonshire Railway, which connected Balloch Pier and Bowling Stations and serviced river shipping. Within ten years Dumbarton became a through station on the line between Glasgow Queen Street and Helensburgh Central Stations. A complete rebuild of the station in 1896 to accommodate further CR and NBR traffic resulted in the construction of two island platforms allowing easier interchange between the different routes. Today Dumbarton Central Station is regarded as a fine example of an urban railway station and is a category A-listed building.

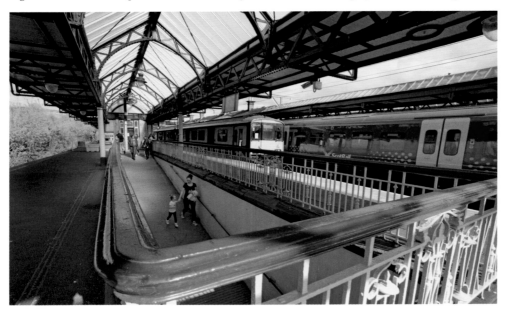

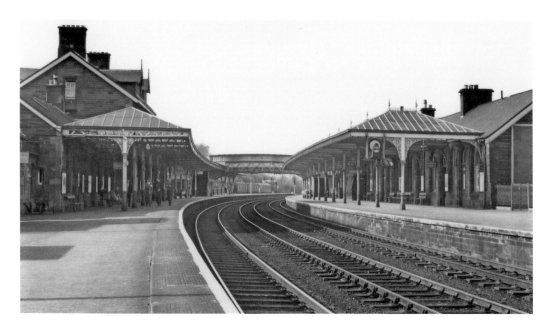

### Dumfries Station and Hotel

Dumfries Station officially opened on 23 August 1848, yet on the following Monday when a train carrying directors and shareholders of the Glasgow, Dumfries and Carlisle Railway Company from Gretna arrived their journey ended at a temporary terminus erected to the east, as the permanent station was still under construction. Two years later the line from Dumfries was extended to Kilmarnock and Glasgow and absorbed into the G&SWR, and become a junction for four other routes, now closed. Although the category B-listed station now carries a much reduced traffic flow, the platforms and remaining buildings give an indication of the size and importance that Dumfries Station once had, reinforced by the splendid Station Hotel. Two of the original buildings on platform one have had a recent facelift and now sport quirky *trompe l'oeil* paintings.

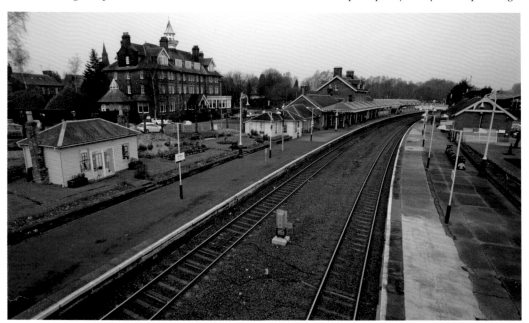

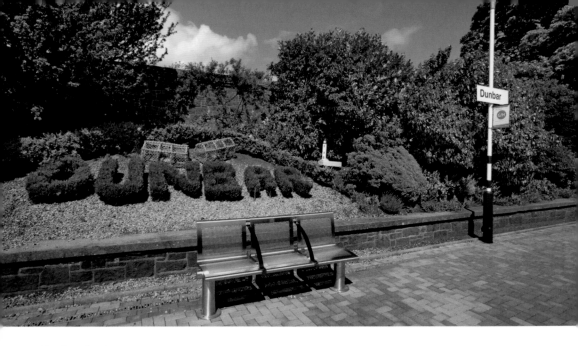

## Dunbar Station

On 8 January 1842 a number of Edinburgh's most influential citizens met in the offices of the Edinburgh and Glasgow Railway to discuss the construction of a 30-mile railway eastwards to Dunbar. As a result the North British Railway Company was inaugurated to undertake the project. A decision was reached to extend the line to Berwick upon Tweed when 'Railway King' George Hudson agreed to construct a railway connection from the south. When the NBR opened its line on 22 June 1846, the first to cross the border, Dunbar Station had two platforms and an overall roof. The redundant northbound platform and the roof were removed during the rationalisation and electrification of the ECML in 1990. The station is now managed by Virgin Trains who encourage volunteers to care for its famous garden, complete with model lighthouse.

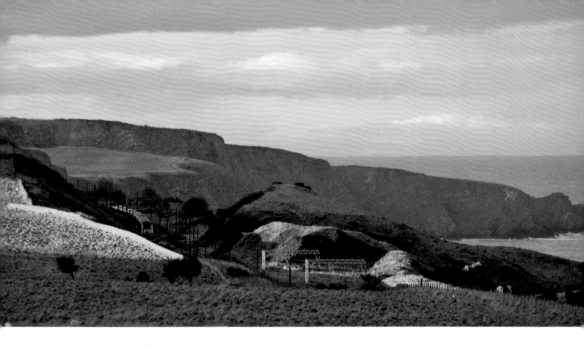

## East Coast Main Line

The section of the ECML between Berwick upon Tweed and Ayton is one of the most romantic stretches of line in Britain. Overlooking the North Sea the line in places runs perilously close to the edge of the cliff, revealing glimpses of crashing waves and cottage rooftops before turning inland to pass the magnificent towers of Ayton Castle. The NBR opened the line across the border between Edinburgh and Berwick in 1846. Over the years the track has been moved further inland for safety. In August 1948, days of continuous rain caused a number of railway bridges to collapse and on this stretch two cliff slippages left the track exposed 150 feet above the shore.

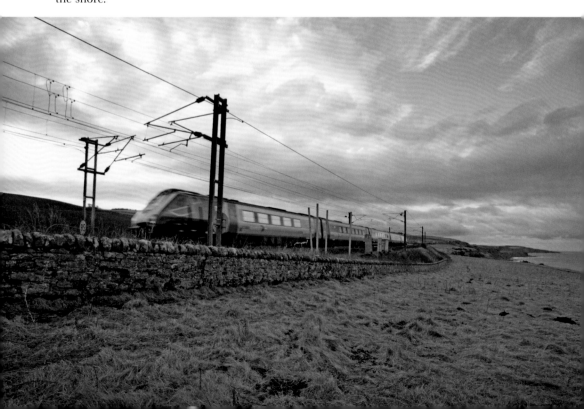

### Edinburgh Caledonian Hotel

Opened in 1903 by the CR, the 205-room Caledonian Hotel, one of Edinburgh's landmark buildings, fronted the company's Princes Street Station. It was a direct response to the North British Hotel opened a year earlier at the opposite end of Princes Street. Designed by Peddie & Browne it was built of the same red sandstone as the station, a statement that 'the Caley', a west of Scotland Railway Company, had a presence in the Scottish capital. The grand arch at the front of the building was formerly the entrance to the station, which closed in 1965. The hotel remained in use and expanded, roofing over the former station concourse, creating the Peacock Alley bar and lounge area. It was sold by BTH in 1981 and recently the category A-listed building experienced a £24 million refurbishment.

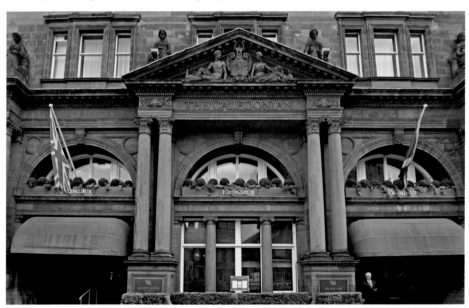

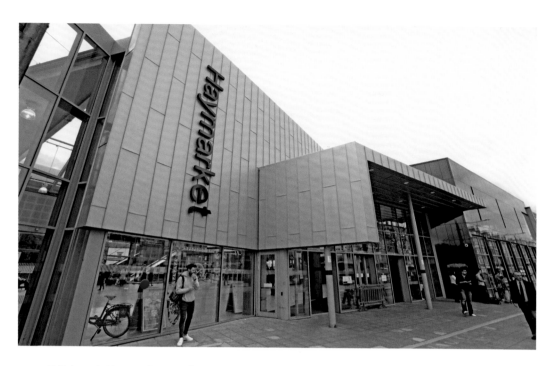

### Edinburgh Haymarket Station

Haymarket was the original terminus of the E&G's high-speed line between the two cities, opening in 1842 as Edinburgh's first station. The old frontage, a two-storey building in classical Georgian style to complement the buildings of the New Town, still exists as a side entrance to the new station and is regarded as an important early railway building. Haymarket became a through station in 1846 when tunnels were built under Princess Street Gardens to a new General Station, providing access to the NBR's North Bridge Station, the line to Berwick and connections to England. As part of a programme to reduce journey times and increase capacity a £25 million scheme has added a new concourse complete with a transparent plastic roof, while outside, the city has constructed an interchange with its tramway system.

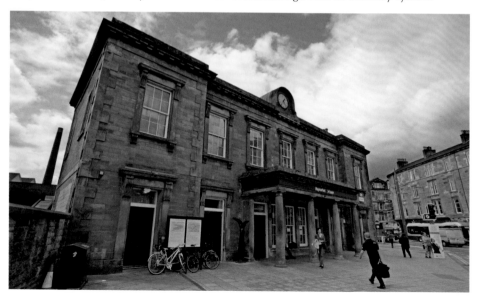

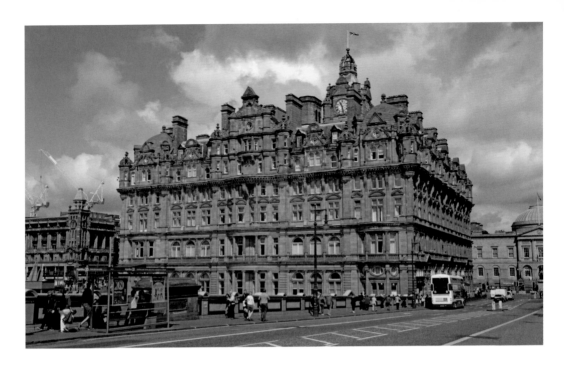

**Edinburgh North British Hotel**

Traditionally known as the 'NB', its doors first opened in October 1902. It was designed by Hamilton & George Beattie for the NBR in a French Renaissance style. Five storeys high with frontages onto Princes Street, North Bridge and Waverley Steps, it was built with 300 bedrooms and fifty-two bathrooms. One of its cellars was used for blending NB whisky, which sold to patrons at 6d (2½p) a glass. The hotel clock was traditionally set two minutes fast, helping passengers catch their trains. Sold by BTH in 1981 it was renamed The Balmoral. The clock tower featured in the 2007 film *Hallam Foe*, and a number of BBC productions have been filmed in and around the hotel. J.K. Rowling finished *Harry Potter and the Deathly Hallows* in 2007 while staying as a guest.

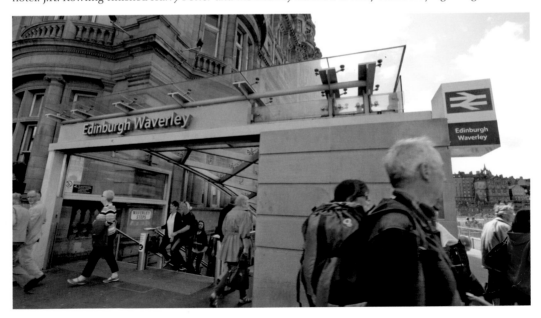

### Edinburgh Princes Street Station

The majestic entrance screen with its cast-iron gates stands in Rutland Street, a visual reminder of the grandeur that was Princes Street Station. In February 1848 the CR opened its Lothian Road Station. By 1870, due to increased traffic, the company built a larger station further north along Lothian Road, renamed Princes Street but known locally as 'Wooden Shanty' due to its timber construction. The station survived until 1894 when a much grander building of red sandstone was completed, with seven platforms and an 850-feet-long roof. Due to its ease of access the station became the preferred route for the monarch when visiting the capital. The station closed in 1965 and is now the site of Edinburgh's financial district. The station clock, still five minutes fast, survives in the Caledonian Hotel.

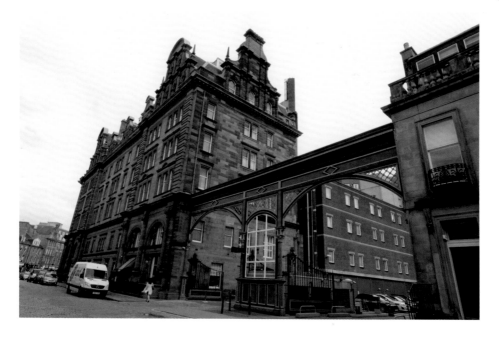

### Edinburgh Trams

Like many towns and cities in Victorian Britain, Edinburgh Corporation developed a tramway system and, like those towns and cities, the tramways were closed in the 1950s, in Edinburgh's case on 16 November 1956. Latterly powered by electricity it was originally horse-drawn then cable-hauled. A relic of the cable system is preserved in the road in Waterloo Place. In the 1990s the city revived its interest in tramways and proposed a new system comprised of three routes. Unfortunately funding and politics whittled the routes down to just one eight and a half mile track between York Place and the airport. Construction began in June 2008 and was completed in October 2013. The final cost of the controversial scheme was £776 million. Opening on 31 May 2014 the tramway carried almost five million passengers in its first year.

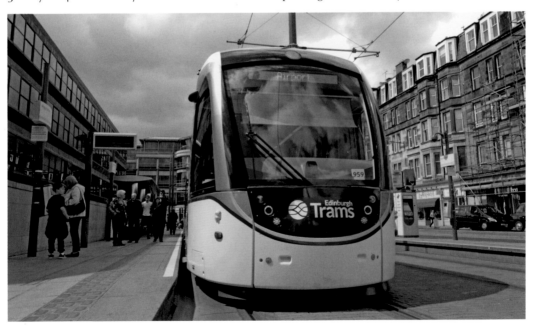

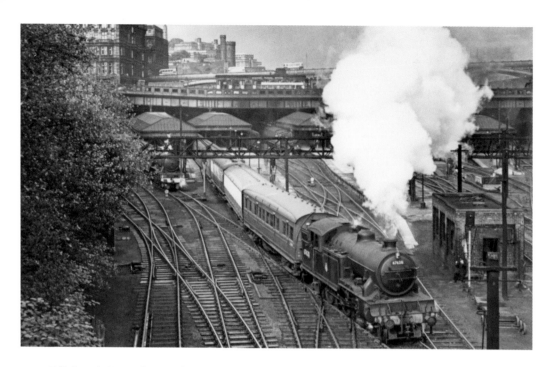

### Edinburgh Waverley Station

From the Scott Monument, Waverley appears as a sea of glass linking the old and new towns and is second only to London's Waterloo as the UK's largest station. The name Waverley, after the novels of Sir Walter Scott, has been used from around 1854. There were originally three stations on the North Bridge site. The NBR opened in June 1846, followed by the E&G's General, and the Edinburgh, Leith and Granton Railways Canal Street, in May 1847. The EL&G site and a ventilation shaft of its Scotland Street tunnel can still be seen in today's station. In 1868 the NBR, having acquired its rivals, demolished all three stations to construct the present station on the site. Recent improvements have included two new platforms, a replacement roof, lifts and covered escalators on the Waverley Steps.

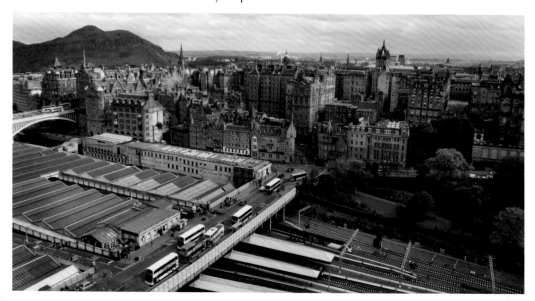

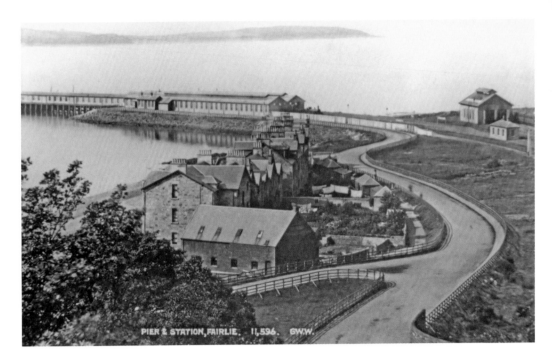

## Fairlie Pier Station

Opened by the G&SWR in 1882, Fairlie Pier Station was ideally placed for servicing steamers to Millport and Campbeltown and also supporting winter sailings to Brodick. The operation proved a great success and fast traffic was timetabled, providing direct trains to Glasgow St Enoch Station. In addition to passengers, trains transported parcels, fertilizer, sheep and cattle to and from the steamers. The last train left the station on 1 October 1971 and the station officially closed on 31 July 1972. The engine shed, now the site of a polytunnel belonging to Organic Growers of Fairlie, was latterly used for boat building and survived until 1987. Today, apart from remains of rails from the branch heading into the trees near the line to Largs, there is little evidence of the existence of the station and pier.

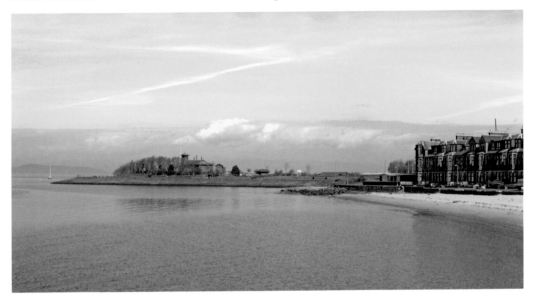

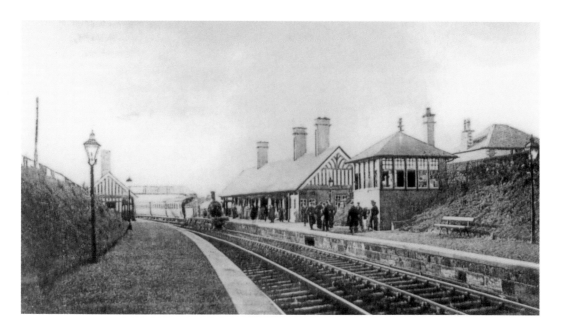

### Fort Matilda Station

The station, designed by James Miller for the CR, opened on 1 June 1889 as an intermediate stop on the Gourock extension. Fort Matilda Station is situated just yards from the western portal of Newton Street Tunnel. The main building survives little changed, a single-storey completed by three single gables onto the street. Along the up platform stood the square signal box, while on the down platform were waiting facilities of complimentary design, the platforms linked by a lattice footbridge. Today the signal box and waiting room have gone but the main building still remains. Sadly the category B-listed building is no longer in use as a station but after being closed and unused for over twenty-five years it has been refurbished and is home to the Greenock and District Model Railway Club.

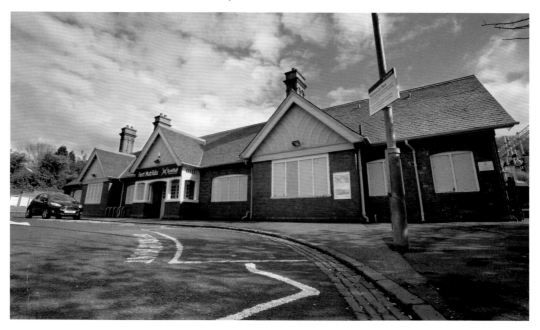

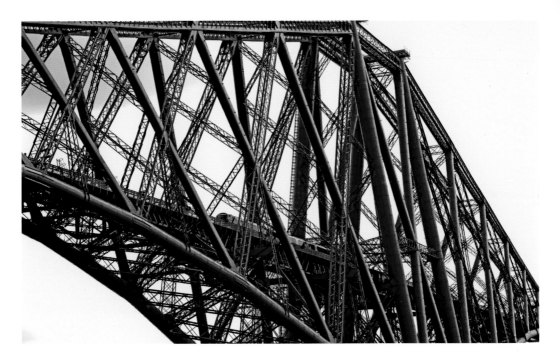

### The Forth Bridge

One of the world's most recognised landmarks, this iconic World Heritage Site is considered by many as the symbol of Victorian engineering at its finest. Even today, standing beneath the immense structure takes your breath away. John Fowler and Benjamin Baker designed the one-and-a-half-mile-long cantilevered bridge between North and South Queensferry for the Forth Bridge Railway Company. William Arrol and Co. was awarded the construction contract and work began in 1882. The bridge was the first major structure in Britain to be made of steel, 53,000 tons of it, and on 4 March 1890 the Prince of Wales drove home the final gold-plated rivet. Today the bridge is resplendent in a finish guaranteed to last twenty years and for the first time in well over a century painting is no longer a never-ending task!

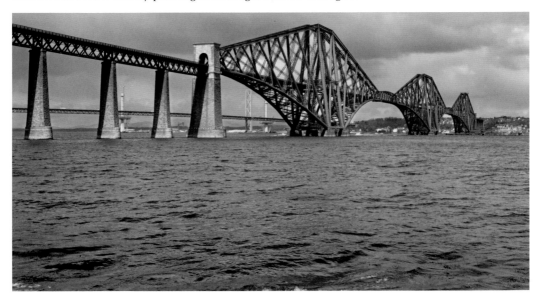

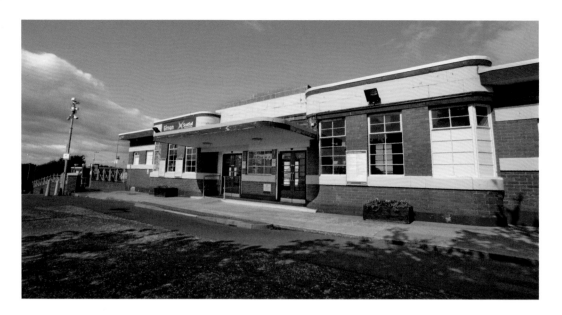

### Girvan Station

Though a fine example of 1930s LMS architecture, Girvan Station was actually completed in 1951. Its 1893 predecessor, built by the GSWR, was destroyed by fire in 1946 and with nationalisation of the railways looming the LMS were not keen to commit to a rebuilding programme. Materials were in short supply so reconstruction did not begin until 1949, utilising an earlier design by architect W. Curtis Green, which today has earned the station and its GSWR signal box a category B-listing. From 1906 until the line's closure in 1942, Girvan Station was the southern terminal of the Maidens and Dunure Light Railway, which served Turnberry and coastal communities to the north. Today the station, which was the railhead for the 2009 Open Golf Championship at Turnberry, could do with a lick of paint!

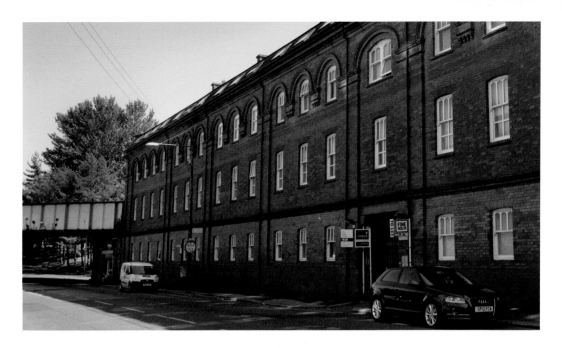

### Glasgow Bell Street

Two contrasting examples of former G&SWR premises dominate Bell Street in the old Glasgow 'toun' area. The huge six-storey category A-listed structure occupying Nos 105–169 was built as a bonded warehouse by the company between 1882 and 1883 at a cost of £100,000 to service the lucrative blended whisky market, an imposing building that would not look out of place in Rome. The rear of the warehouse had direct access to the College Railway goods yard, closed in 1968. Across Bell Street at No. 174 the company constructed a three-storey stable block, which is category B-listed. Built in 1900 the ground floor of the terracotta brick building was used for cart storage, the first floor for stabling and the upper floor to house grain and hay. Today both buildings have been converted into apartments.

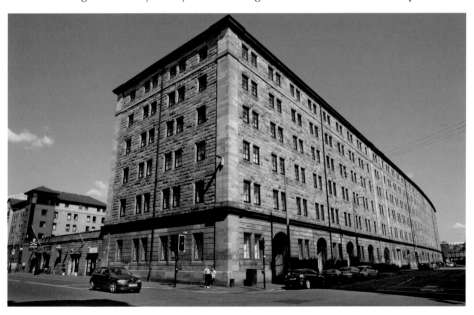

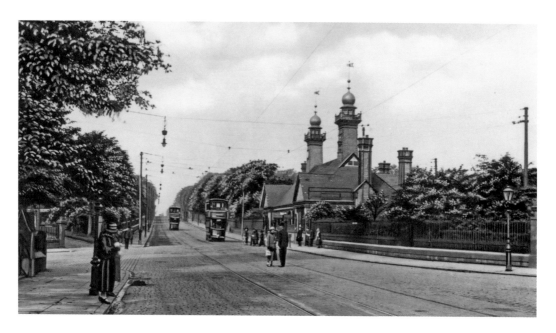

## Glasgow Botanic Gardens Station

Today one can only view the underground remains of Botanic Gardens Station through air vents situated deep in the undergrowth at the south-eastern corner of Glasgow's Botanic Gardens. Looking down one might be viewing a huge terrarium filled with exotic plants. The station was opened in 1896 as part of the CR's Glasgow Central Railway. Facing onto the Great Western Road the ornate building above ground was of Russian Orthodox influence, designed by James Miller. The station closed in 1939 as a wartime economy though the line continued until passenger services stopped in 1964. A fire on 22 March 1970 led to the demolition of the station buildings, which then housed a café, a plumber and a nightclub. The derelict platforms became the setting for Hamish Macdonald's 2001 novel *The Gravy Star*.

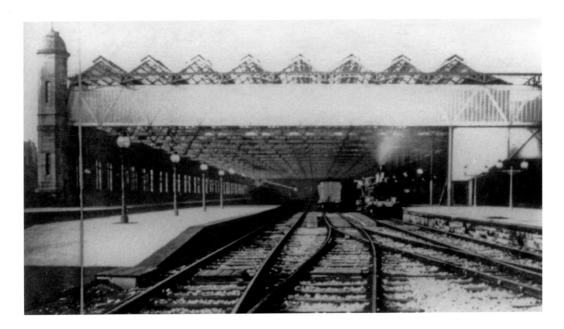

### Glasgow Bridge Street Station

Bridge Street Station opened on the south bank of the River Clyde in 1840, the first purpose-built station for passengers. It was the terminus for Clyde railway traffic and jointly operated by the G&SWR and CR. The Glasgow legal profession benefited greatly from this arrangement as the companies constantly squabbled about the use of the station. In truth they wanted a location closer to the city centre but were continually blocked by the city fathers. Eventually the G&SWR got its wish and constructed St Enoch Station while the CR moved directly across the river to the newly constructed Central Station. Bridge Street then operated as a through station and carriage sidings until it was eventually demolished. Today James Miller's category B-listed French Renaissance-style addition to the station can still be seen fronting Bridge Street.

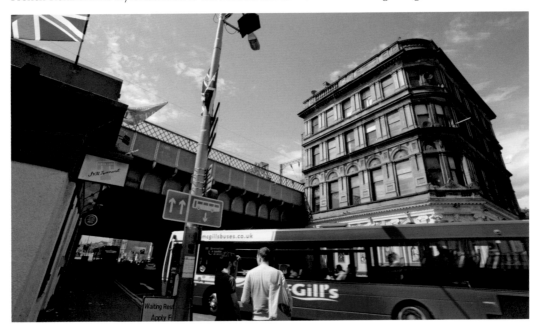

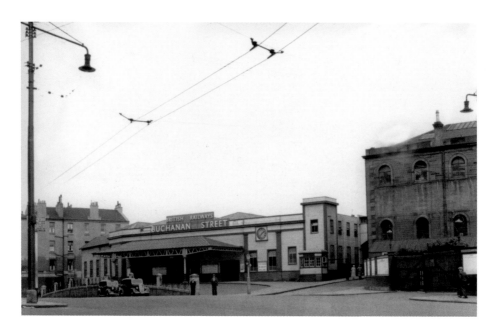

## Glasgow Buchanan Street Station

Buchanan Street Station was a victim of Dr Beeching's rationalisation of the railways and closed in 1966. It was the least imposing of all Glasgow's main line terminuses and of little architectural merit. It was said that a chemical works or charnel house was cheerful by comparison, which was surprising for the CR, given the quality of its other buildings. In fact the company's goods station next door was much more arresting. Built in 1849, Buchanan Street Station predominantly serviced traffic from the north-east of Scotland, Aberdeen, Perth and Stirling. The station buildings were temporary wooden structures, which were in use until a reconstruction in 1933. The platform canopies were second hand, having been taken from Ardrossan North Station. Today Buchanan House occupies the site, until recently the Scottish headquarters of Network Rail.

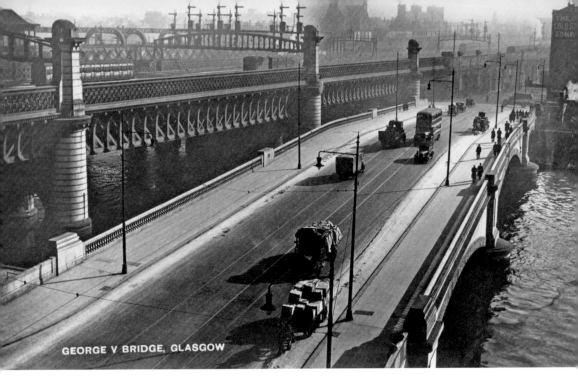

GEORGE V BRIDGE, GLASGOW

## Glasgow Caledonian Railway Bridge

Despite all its efforts the CR were unable to gain a foothold on the north bank of the River Clyde. For thirty years interested parties, including Glasgow Corporation, frustrated the company's attempts to build a city centre station. Eventually in 1873 the CR obtained an act authorising the bridging of the river and the development of a new station. The resulting bridge, built by William Arrol of Glasgow, was 700 feet long and 55 feet wide with four tracks. By 1900 a second bridge with eight tracks was under construction as part of Central Station's expansion and a signal box with a 374-lever frame was constructed, slung between the bridges. Again the contractor was Arrol. The girders and tracks of the first bridge were removed in the 1960s and today only the pillars remain.

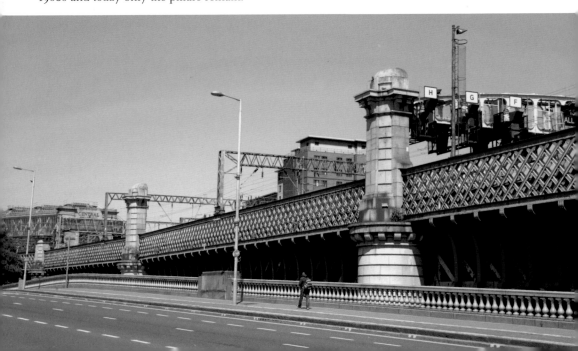

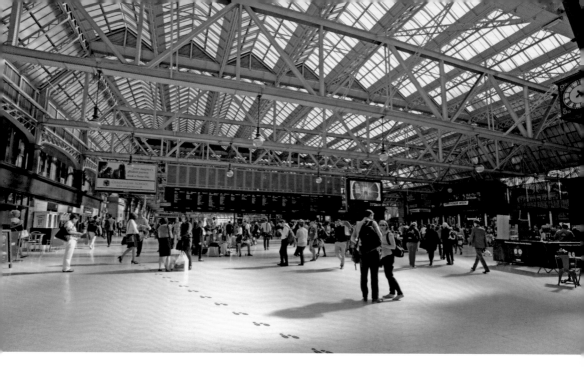

## Glasgow Central Station

In 1879 the CR opened the magnificent Central Station, one of the city's most iconic spaces and the busiest station outside London. It was built with eight platforms and linked to Bridge Street Station by Sir William Arrol's four-track river bridge and a further bridge over Argyll Street. The low level platforms were a separate station serving Glasgow Central Railway. Between 1901 and 1905 the station was rebuilt. It was extended across Argyll Street and thirteen platforms were constructed. A new eight-track bridge was built over the Clyde, engineered by Arrol, and a series of sidings were created. Electrification took place in the 1960s, and 2010 saw two newly constructed platforms brought into operation. A year later, in a controversial effort to stop fare dodging, automatic ticket barriers were installed to all but two platforms.

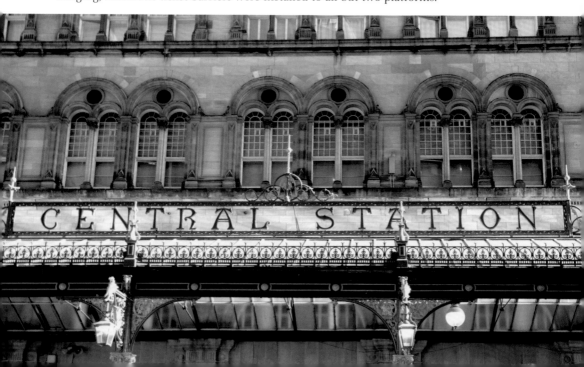

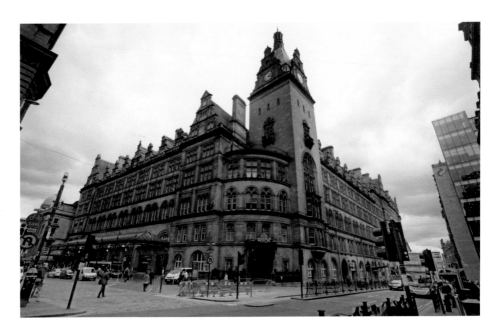

### Glasgow Central Station Hotel

Architect Robert Anderson's Queen Anne-style Central Station Hotel, built for the CR, welcomed its first guests in 1883. By 1907 the hotel had been extended by architect James Miller and formed the frontage to the Central Station, directly adjoining the main concourse. As one of city's most prestigious and grandiose establishments it attracted guests such as John F. Kennedy, Frank Sinatra, Laurel and Hardy, Danny Kaye and even Roy Rogers and Trigger! John Logie Baird transmitted the world's first long-distance TV pictures to the hotel in May 1927. In the 1980s British Rail, bowing to government pressure, broke up BTH and the 'Central' was sold by open tender. Today the category A-listed and retitled Grand Central Hotel is part of a large hotel group, its public rooms elegant and stylish.

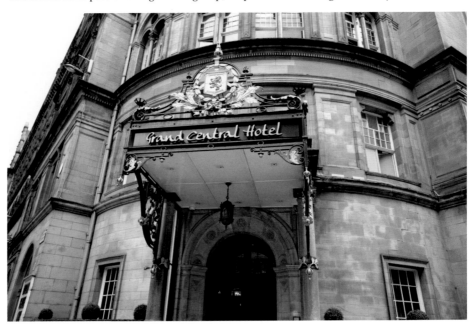

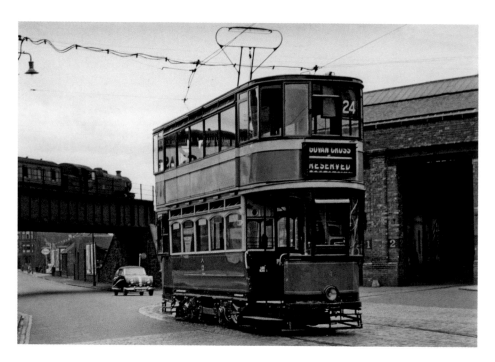

## Glasgow Corporation Tramways

The trams, synonymous with Glasgow, were used – and loved – by all. Enactment of the Glasgow Street Tramways Act by Parliament in 1870 led to the creation of one of the largest urban tramway systems in Europe, with over 1,000 trams serving the city on over 100 route miles of track. Using a gauge of four feet seven and three-quarter inches allowed standard-gauge railway wagons to use the tracks around the shipyards. Tram drivers, men and women (from the First World War onwards) considered themselves as the elite, the men even wearing their caps in the tradition of guardsmen. On 4 September 1962 over 250,000 emotional Glaswegians watched a final-day procession of twenty-two trams through the city. Today the former workshops at Coplawhill, Pollockshields, survive as home to 'Tramway', an international art-space.

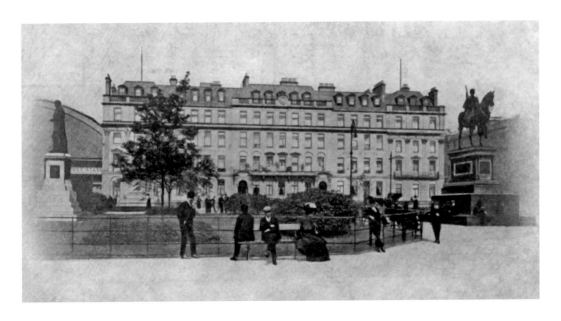

## Glasgow North British Hotel

The imposing building that would eventually become the North British Hotel was built as three townhouses between 1807 and 1818 on the north side of the newly laid-out George Square. Sir William Burrell, the great philanthropist and shipping merchant, was a resident of townhouse No. 47. The three houses were converted into three separate hotels around 1855, The Queen's, visited by Queen Victoria in 1888, The Royal and The Crown. The building was acquired by the NBR in 1903 and all three concerns were converted into one entity with a top floor created from the attic. After nationalisation the hotel was managed by BTH until it was sold in 1984. Today, renamed The Millennium Hotel, it has a category B-listing and is the only surviving original building on the square.

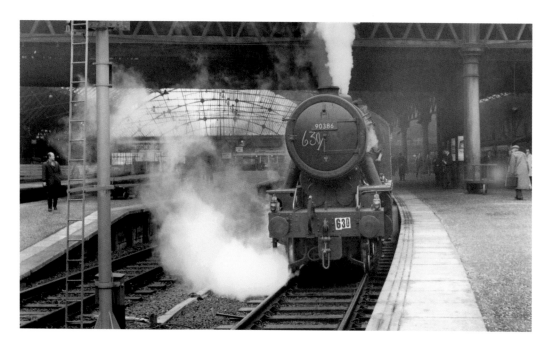

## Glasgow Queen Street Station

Queen Street is Scotland's third busiest station, its huge, single-span roof creating a vast and airy space. The station opened on 18 February 1842 as the Glasgow terminus of the E&G. North of the station Cowlairs Tunnel, over half a mile in length, carries the railway below the Cut of Junction canal. The gradient through the tunnel and up the bank to Cowlairs is 1 in 41 and until 1908 all trains were rope-hauled by a stationary steam engine. From then until the end of steam, banking engines with slip couplings propelled the trains from the rear. Queen Street Station is on two levels, the high-level platforms running north and the low-level ones servicing east–west traffic. A surviving E&G milepost was placed above the platform 2 buffers in 2008.

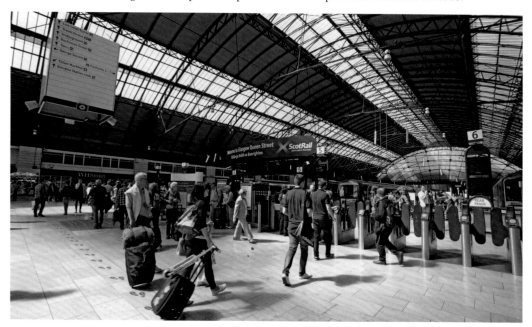

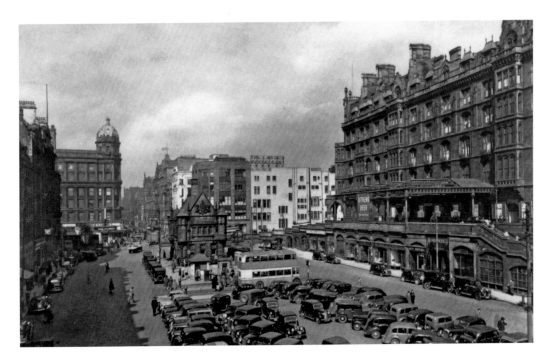

## Glasgow St Enoch Hotel

Said to be a fitting accompaniment to the iron train shed behind, Scotland's largest hotel was opened in 1879 by the G&SWR. Built in a Gothic style similar to St Pancras Station in London, St Enoch Hotel was one of the most imposing buildings in Glasgow. Designed by Thomas Wilson of Hampstead and Miles Gibson of Glasgow, the frontage facing St Enoch Square was 360 feet long and 120 feet high, six storeys, with the north wing, some 500 feet in length, extending to Dunlop Street. The hotel boasted 200 bedrooms and twenty public rooms, and along with the station was the first building in the city lit by electricity. St Enoch Hotel closed in 1974 and, despite protests, was demolished in 1977, the rubble used to fill Queen's Dock on which the SECC now stands.

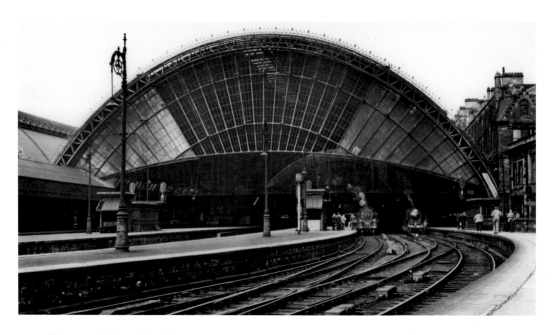

### Glasgow St Enoch Station

St Enoch Station opened as a terminus in 1876. John Fowler and James Blair designed the station to fit into a restricted site, which required sharply curved approaches. It shared similarities of design to London's St Pancras, even to the addition of a large station clock, no coincidence as the Midland Railway was an associate of the G&SWR. The overall five-centred arched roof made of wrought iron had a span of 205 feet and a length of 525 feet, covering six platforms. Between 1898 and 1902 the station was extended with six new platforms and a second arched roof. The station closed in 1966 and was demolished in 1977. The St Enoch Centre, nicknamed 'The Glasgow Greenhouse', now occupies the site – a shrine to today's retail aspirations. The clock survives in the Antonine Centre, Cumbernauld.

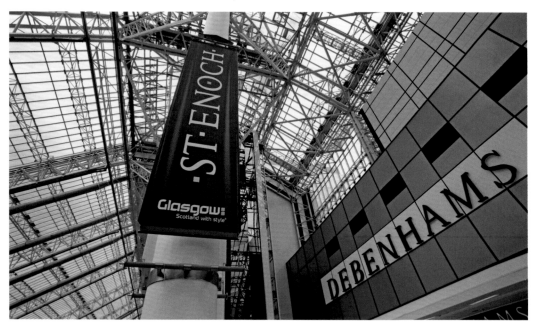

### Glasgow Subway

Opening on 14 December 1896 the Subway is the third-oldest underground metro system in the world and is a reflection the city's confidence at that time. The route is a six-and-a-half-mile, fifteen-station loop running north and south of the river. The four-feet-gauge railway, originally cable-hauled, was electrified in 1935 using a third 600-volt-DC live rail. Until the 1970s' modernisation programme stations were very basic and said to have a unique aroma recognisable to all Glaswegians. Modernisation repaired tunnels, rebuilt stations and platforms; and a new interchange was built at Partick. New rolling stock sporting an orange colour scheme was introduced prompting the popular 'Clockwork Orange' nickname from proud Glaswegians. Though plans to extend the system for the 2014 Commonwealth Games did not materialise, a £290-million long-term station refurbishment programme is underway.

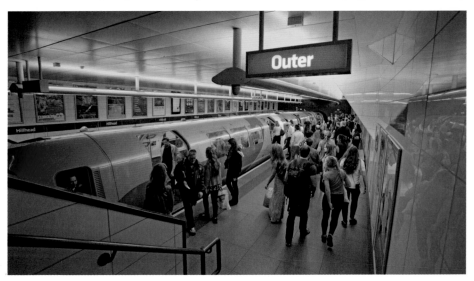

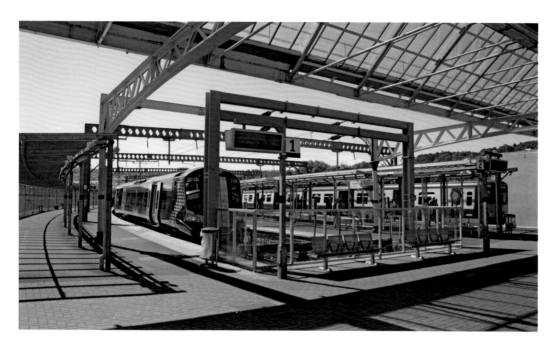

### Gourock Station

Gourock Station was a hugely successful concept that survived for almost a century. Designed by James Miller, the station was built for significant passenger numbers and was larger than the rival G&SWR Princes Pier. In 1869 the CR laid out plans for an international port at Gourock, which were blocked by both the G&SWR and Greenock authorities. Undaunted, the CR introduced another scheme for a station, passenger pier and rail link from Greenock Central Station. Gourock Station opened in 1889 at a cost of £600,000, which included the construction of three tunnels. The curving structure had seventeen canopied bays on either side of three railway lines, a central concourse and offices. Today the grand station has disappeared, replaced by an £8 million modular building with waiting room, booking office, and a sheltered walkway to the ferry terminal.

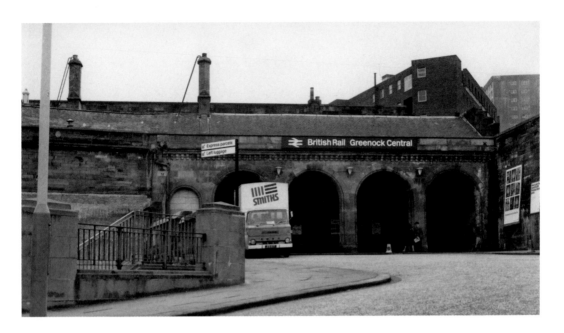

### Greenock Central Station

A shadow of its former self, the station, known as Cathcart Street when it opened in 1841, was the terminus of the Glasgow, Paisley and Greenock Railway and one of eight stations that would serve the town. The company offered steamer connections to eight Clyde resorts from Custom House Quay. The quay was 300 yards away from the station via the unsavoury East Quay Lane. Transportation to the quay was available for women, children and luggage, however men were encouraged by the company to 'walk quickly or run to avoid trouble'. Greenock Central became a through station when the Gourock extension opened in 1889. The station was electrified in 1967 and, with the roof removed, a new booking office has been constructed while the north side of the concourse is now a car park.

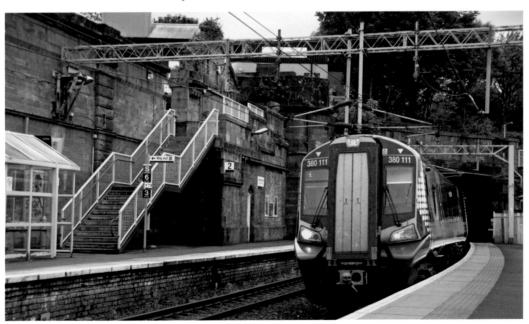

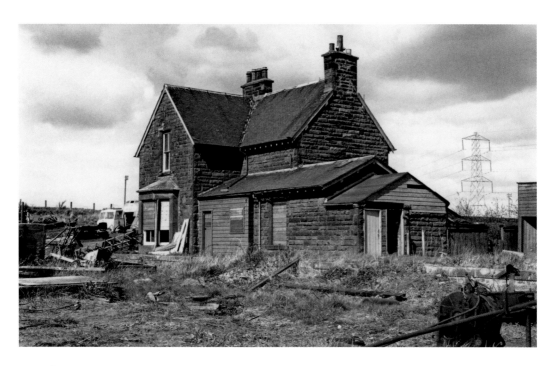

## Gretna

Railway Mania did not always prove popular with the locals – take Gretna for instance. The CR opened the first station just south of the border in 1847. The following year the Glasgow, Dumfries and Carlisle Railway, soon to be the G&SWR, opened their Scottish station. Finally the NBR completed the terminus of a branch from the Waverley Route in 1861, again on English soil. This led to an avalanche of complaints that railway traffic from England had created a surge of Gretna Green 'anvil' marriages. Meanwhile overworked customs officers struggled desperately to apprehend railway employees and passengers smuggling whisky south across the border, not to mention the Church of Scotland objecting vociferously to the G&SWR undertaking shunting in Gretna on a Sunday. The company quickly moved such operations south to Carlisle. A new station was opened in 1993.

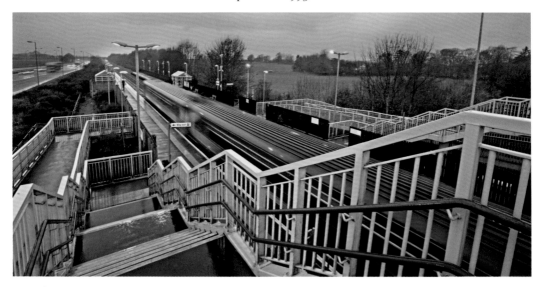

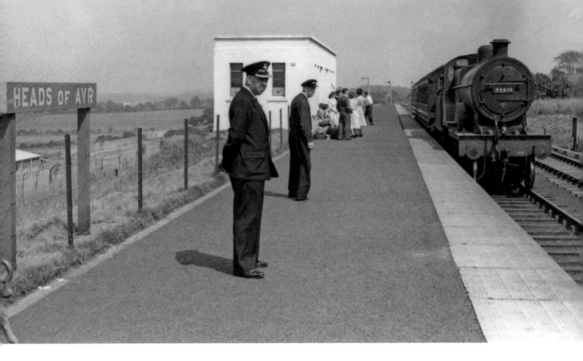

### Heads of Ayr Station

During the Second World War and at the request of the Admiralty, Billy Butlin procured eighty-five acres of coastal land at the Heads of Ayr and constructed a camp. Opened in 1941, Royal Navy Training Establishment HMS *Scotia* served the Admiralty well until it was handed back to Butlin in 1946. Quickly spruced up and with a gala public opening by Sir Harry Lauder, Butlin's Holiday Camp proved very popular, so popular that a stretch of the closed Maidens and Dunure Light Railway between Alloway Junction and Heads of Ayr which closed in 1933 was reopened, complete with a newly constructed station to welcome the holidaymakers. The rail operation continued against increasing road competition until losses led to closure in September 1968. Today's camp, renamed Craig Tara, now operates using predominantly static caravan accommodation.

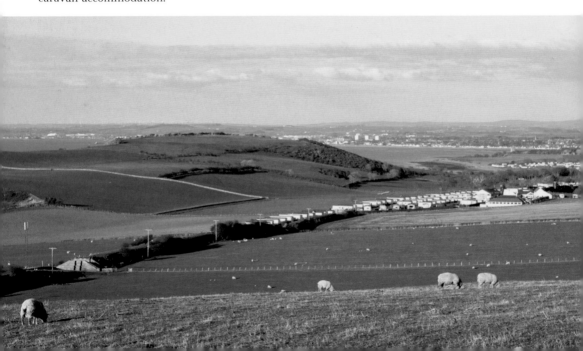

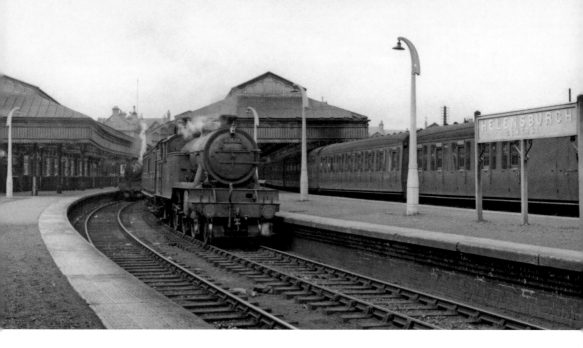

## Helensburgh Central Station

Helensburgh Station, the terminus of the Glasgow, Dumbarton and Helensburgh Railway Company, opened in 1858. The company aimed to open a packet station on the River Clyde but the residents of the town consistently blocked plans for a rail link between the station and the pier. Frustrated by the opposition the company transferred its steamboat operation to a new station and pier at Craigendoran. Meanwhile the company was absorbed into the NBR in 1865. The station adopted its present name in 1953, with electrification following under British Railways' modernisation plan in November 1960. The buildings, gates, platforms, canopies and screen walls of this pretty, airy station were designated category B in 2002. Today three of the four original platforms are still in use and provide an invaluable connection for commuting and shopping trips to Glasgow.

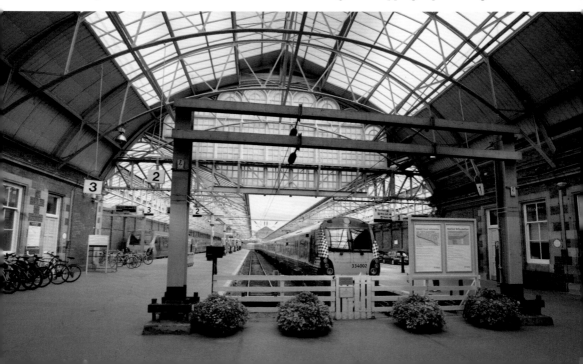

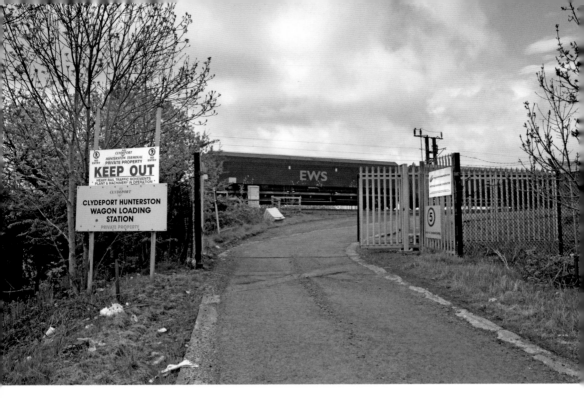

### Hunterston Wagon Loading Station

Hunterston Wagon Loading Station is part of the huge Hunterston Coal Terminal site, completed in 1979 as one of the premier deep-water ports in the world. Originally built for the delivery of iron ore for British Steel's Ravenscraig Steelworks, which closed in 1992, the terminal now handles coal imported from as far away as Columbia in South America. Coal is transported across the site on conveyors from the ships to the loading station, where it is loaded into coal hoppers as they are pulled through the plant by their locomotives. From here the twenty-two 'merry-go-round' hopper trains carrying up to 1,750 tonnes of coal, currently feed Longannett Power Station on the northern shores of the Firth of Forth and power stations further afield in Yorkshire.

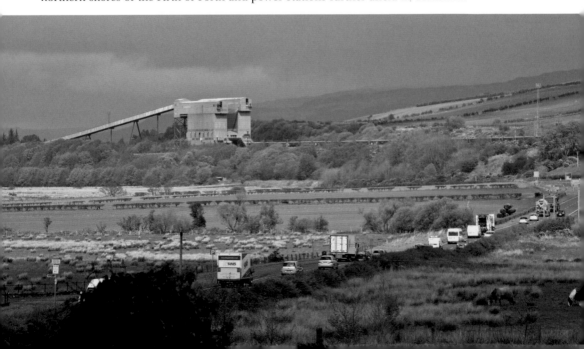

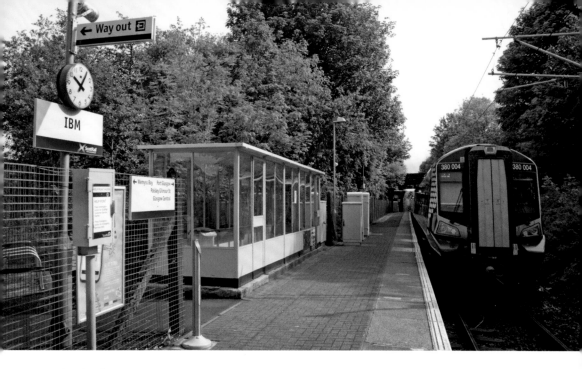

## IBM Station

On the south side of the Spango Valley above the A78 Greenock-to-Inverkip road lies IBM Station. The halt was opened on 9 May 1978 to provide rail transport for over 4,000 employees of the multinational computer manufacturing company IBM and, as it served only the facility, it was an unadvertised peak-time stop. However, after transferring manufacturing to Asia and Eastern Europe, IBM sold the site to another electronics company Sanmina, who themselves pulled out of the plant in 2006, moving 370 jobs to Hungary. Today many of the original buildings have been demolished and the rather sad looking site has been rebranded as Valley Park. The station, still known as IBM, is now timetabled and open to both Valley Park employees and the general public.

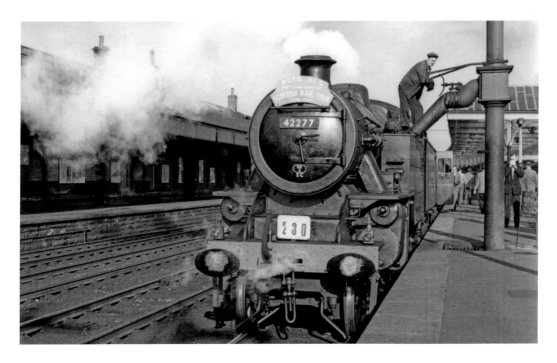

### Kilmarnock Station and Viaduct

The tower of the deep red sandstone station is a striking landmark in the town. Kilmarnock opened its first railway station in 1812. Built by the Kilmarnock and Troon Railway it was one of the earliest in Scotland. The present station dates from 1846, constructed by the Glasgow, Paisley, Kilmarnock and Troon Railway Company. The station quickly developed into a major hub for the railways of south-west Scotland, which continued until the Beeching cuts of the 1960s. The impressive viaduct at the south end of the station, designed by Grainger and Miller, was built in 1848 and its twenty-three arches dominate the skyline as it strides across the town centre. Today the station and the viaduct are category B-listed. The station connects with Glasgow and Carlisle and services to the Belfast ferry at Stranraer.

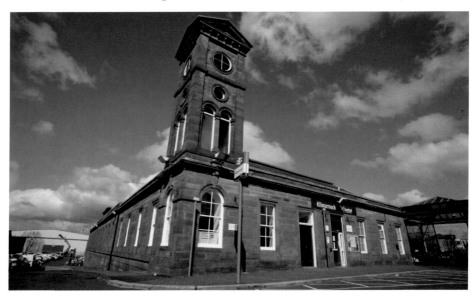

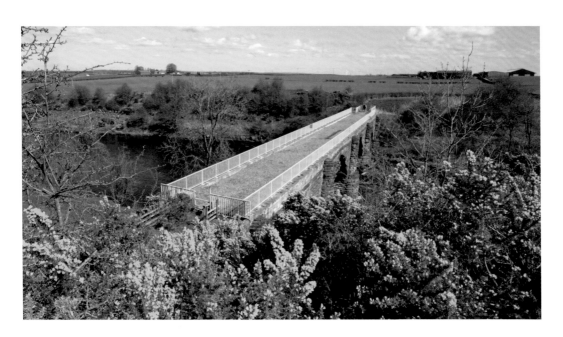

### Laigh Milton Viaduct

Once known as Milton Bridge and commanding a picturesque location across the River Irvine, the 270-feet-long Laigh Milton Viaduct is probably the oldest surviving viaduct on a public railway in the world. Standing twenty-five feet above the water the category A-listed structure, engineered by William Jessop, was built as part of the 1812 Kilmarnock and Troon Railway. Originally developed as a double-track, four-feet-gauge wagonway with L-shaped cast-iron plate rails, it carried horse-drawn carts of coal from the Duke of Portland's pits around Kilmarnock to Troon Harbour. The railway was to carry freight only, but passengers were carried for a shilling (5p). The viaduct closed in 1846 when the line was realigned in order to accommodate steam locomotives, and a new crossing was built downstream.

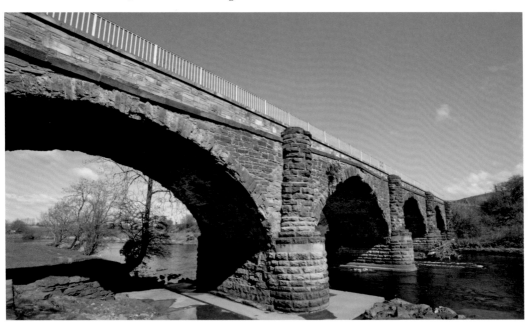

## Largs Station

Largs Station opened in 1885. The GSWR recognised the town's potential as it had a pier where steamers called on the way to Millport and other Clyde resorts. The intention was for a line to the town from Kilmalcolm but finally an extension from the Ardrossan branch prevailed. The station originally had four platforms but after electrification in 1987 it was reduced to two. Today the station yard and shed are part of a supermarket complex. On 11 July 1995 an EMU Class 318 from Glasgow Central entering the station failed to stop. Ploughing through the buffers, the ticket office and the station building, it demolished two shops before coming to rest in the main street's taxi rank, thankfully with no fatalities. The station was subsequently demolished and a modest £200,000 rebuild was completed in 2005.

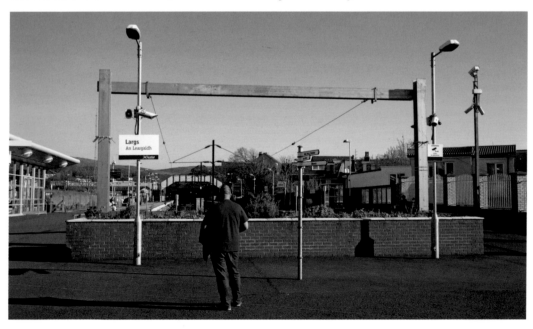

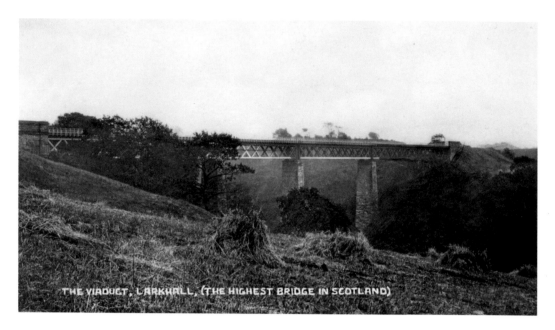

THE VIADUCT, LARKHALL, (THE HIGHEST BRIDGE IN SCOTLAND)

### Larkhall Viaduct

Scotland's tallest railway viaduct, standing high above the deep and wooded Morgan Glen, is a rusting, rotting, vandalised category B-listed structure, categorised as 'at risk'. Built by the CR as a part of a four-and-a-half-mile connecting line between the Lesmahagow and Stonehouse branches, it opened on 1 July 1905. The six-span, 150-feet-high and 770-feet-long bridge over the Avon Water sits on piers with foundations up to 60 feet deep. When completed the viaduct was subjected to severe load testing, including a twelve-locomotive train with a combined weight of 780 tons crossing at speed. The line closed in October 1965 and the viaduct was sold to a property developer, and despite two applications for demolition, the skeletal edifice survives today.

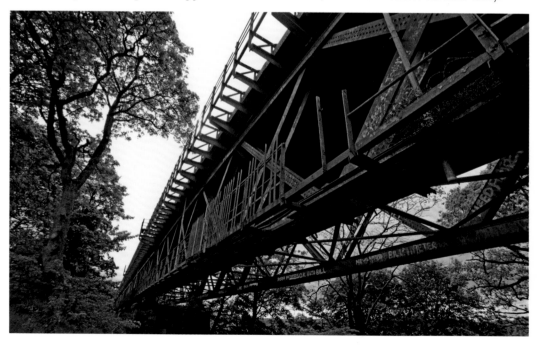

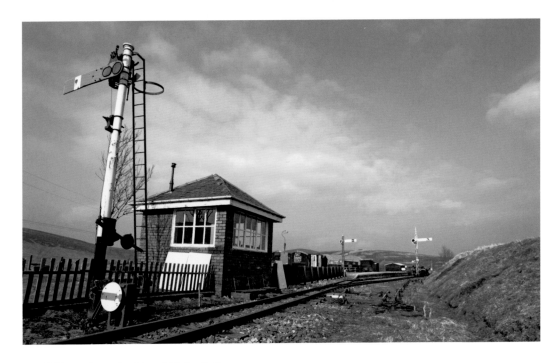

## Leadhills and Wanlockhead Light Railway

Just over seven miles in length, this very remote single-track branch to Scotland's highest village Wanlockhead opened in 1902, connecting to the mainline at Elvanfoot. Engineered by Sir Robert McAlpine, 'Concrete Bob', a fine example of his work, Rispin Cleugh Viaduct clad with bricks, at the behest of the locals stood until 1991. To satisfy passenger and parcels demands the CR ran a train consisting of a carriage and van stopping on request. Though it was from the mineral traffic that the company expected to prosper. The revival of the lead mining industry did not materialise and the profitless railway closed in 1939. Volunteers have laid a mile of narrow-gauge railway on the trackbed at Leadhills complete with a visitor centre, and working signal box, with trains running frequently on weekends during the summer months.

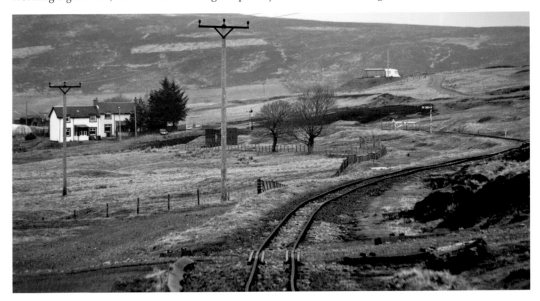

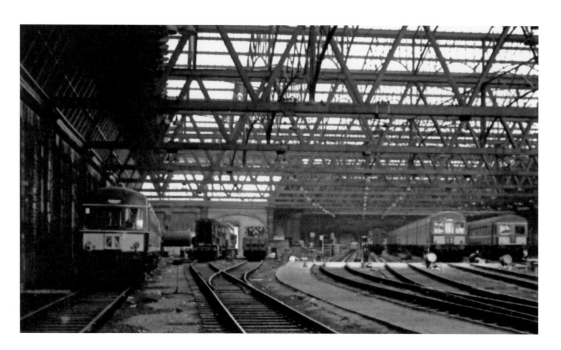

### Leith Central Station

Competing for suburban traffic the NBR opened Leith Central Station, the terminus of a short branch line from Waverley Station, in July 1902. The station had a two-storey frontage, a clock tower and a massive train shed over 100 yards in length, complete with four platforms, fifteen feet above street level. The Leith Council paid for the electricity illuminating the clock as the NBR insisted that it benefitted the public. Competition from trams and then buses led to the station's closure in 1952. The building continued as a motive power depot until the early 1970s when it was closed. The abandoned building became a haven for alcohol and drug addicts, inspiring the title of Irving Welch's 1993 novel *Trainspotting*. Today only the frontage remains – the shed having been replaced by a leisure centre and supermarket.

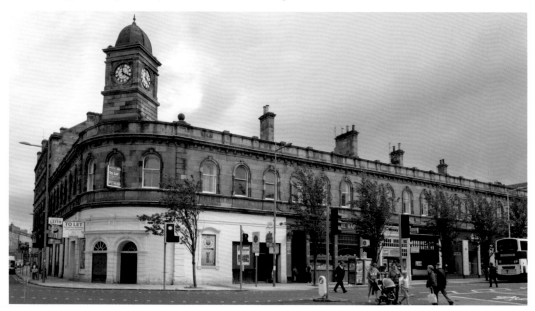

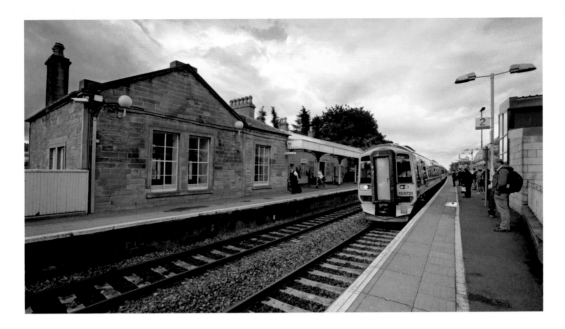

## Linlithgow Station

Linlithgow Station is the subject of what is probably the world's earliest photograph of a railway station. Edinburgh's David Octavius Hill and Robert Adamson captured a view across the station towards the Linlithgow Palace in 1845. The station had opened as a part of the E&G on 21 February 1842, not without controversy, as only days before the opening the provost, bailies and council of the town had informed the railway company that they intended to evoke ancient charters and an Act of Parliament which would allow them to invoke levy duties on all wagons and carriages passing through the station. A court hearing began in 1843, lasted ten years and found in the railway's favour. Today the two-storey sandstone station building, despite late-Victorian alterations, is recognised as one of the best preserved in Scotland.

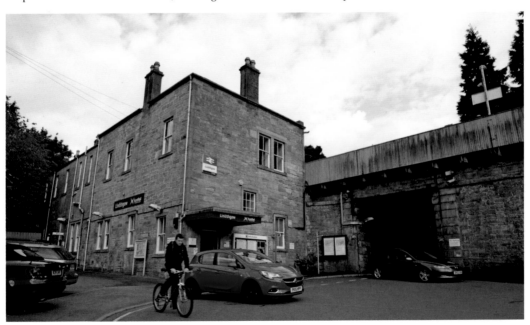

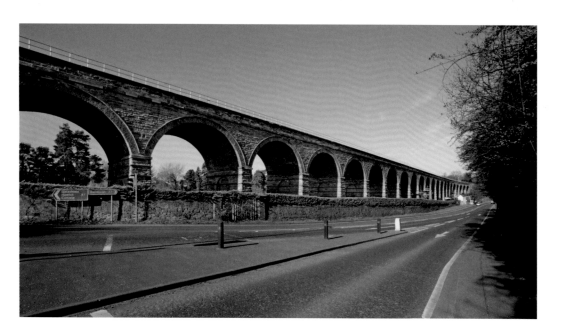

### Lothianbridge Viaduct

Lothianbridge or Newbattle Viaduct was completed in 1847, the second viaduct on the site and designed by John Miller. Built by the NBR to carry the Waverley Route across the River Esk, the twenty-three arch category B-listed structure is one third of a mile in length, having a skew arch to accommodate the A7. The railway closed in January 1969 and the viaduct stood for over forty years as a monument to its glorious past. Reinstated as part of the Borders Railway the viaducts stonework was repaired and repointed, and new track work installed ready for the line's opening in September 2015. A comparison with the newly built Hardengreen Viaduct less than a mile away on the same line demonstrates the change in construction techniques and building materials over the last 150 years.

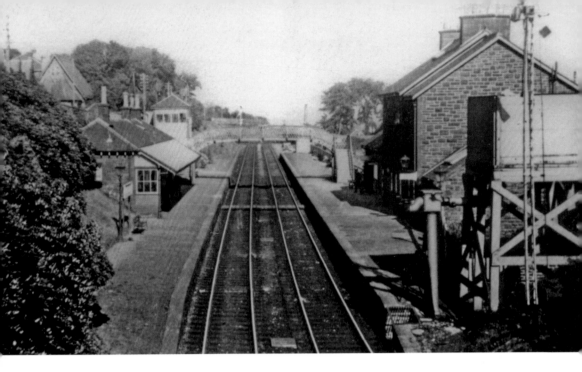

## Maybole Station

The star attraction of Maybole Station must be the Escher-like, labyrinthine architecture of the footbridge. In order to comply with accessibility regulations the quantity of ironwork in such a confined space is positively mind-blowing. The original Maybole Station, a terminus of the Ayr and Maybole Junction Railway, opened to goods traffic on 15 September 1856. Due to dissatisfaction with the ballasting the inspecting officer delayed passenger services for another month until 13 October. Four years later, on 26 May 1860, the Maybole and Girvan Railway opened its line south from Maybole. Rather than adapt the terminus, the company chose to open a new Maybole Station west of the existing station, with a more conventional footbridge. The terminus then became a goods depot until its closure in 1965. Today the main station building contains a convenience store.

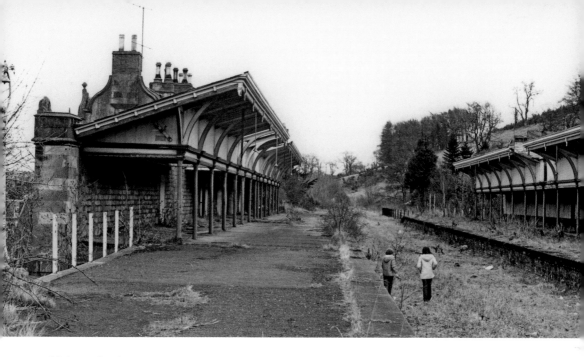

## Melrose Station

Road traffic now thunders past the up platform of Melrose Station. Here the trackbed of the NBR's Waverley Route to the English border now forms part of the A6091. Many of the larger stations on the line have been demolished but architect John Miller's magnificent main building, designed in 1846 to accommodate the town's increasing tourist trade, has survived. It was built on two levels in Jacobean style. The lower level accommodated the stationmaster and staff, and the upper contained the booking office, waiting rooms and toilets, and gave access to the timber-and-iron-canopied platform. A lattice footbridge connected the staggered, similarly canopied down platform, complete with its 'Iron Duke' urinal. In 1981 the station building was listed category A. Today a growing campaign calls for an extension of the Borders Railway to Melrose.

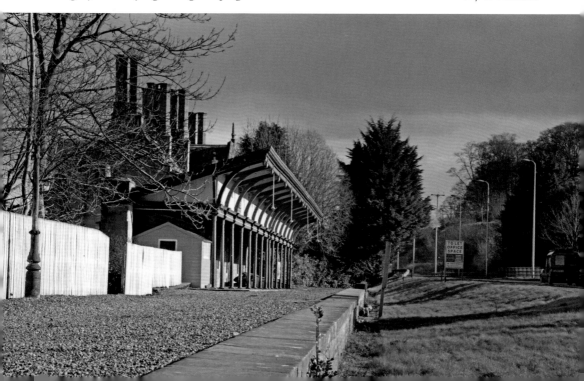

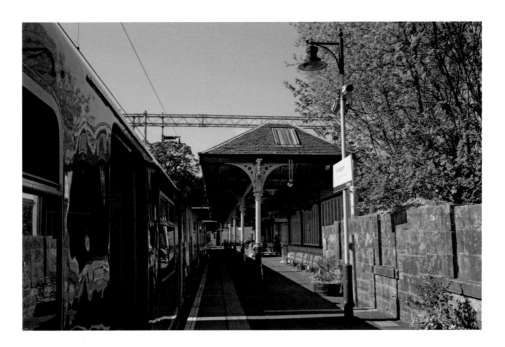

## Milngavie Station

Today this charming category B-listed station with its elegant ironwork is well known for its award-winning floral decorations, and is perfectly suited to its suburban setting. The single-storey building, which houses the station offices, had slated and glazed awnings supported by cast-iron columns and girders that were added in the 1890s. Milngavie Station was opened in 1863, the terminus of the Glasgow and Milngavie Junction Railway, which was eventually merged with the NBR. The district had a small population but the shareholders were attracted by the potential for high-class residential development. The station was originally built with three platforms though one has since been removed. It was near here in a derelict siding that George Bennie's experimental Railplane System was constructed in the 1930s. The track from Hillfoot was singled in the early 1990s.

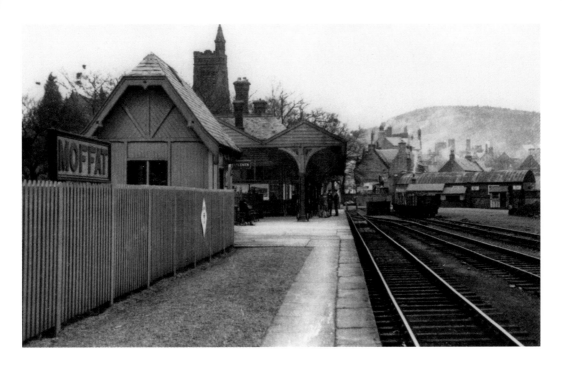

## Moffat Station

The spa town of Moffat was a favourite with 'fashionable people' long before the railway's belated arrival in 1883. The CR had preferred to build its 1848 main line to the west and only after vigorous local promotion was a two-mile branch line constructed across the valley from Beattock Station. Such was the popularity of the resort that the *Tinto Express*, a direct train from Glasgow to Moffat, was timetabled. Latterly the town was served by a steam railcar nicknamed the 'Moffat Bus'. Passenger services ceased on 6 December 1954, though goods traffic continued for another ten years. Today all that remains of the station is a short section of platform and the station's rustic-styled wooden toilet building, incongruously situated between the Station Park on one side and a supermarket car park and petrol station on the other.

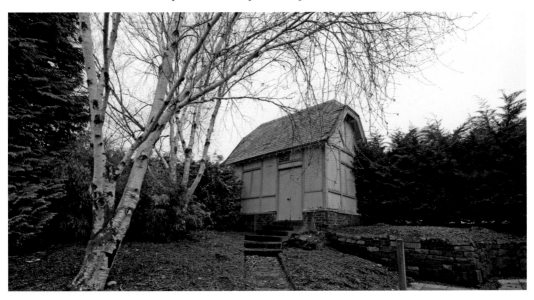

## Moniaive Station

Moniaive Station, the northern terminus of the G&SWR Cairn Valley Light Railway, now stands alone and neglected at the edge of a field just off Chapel Street. The goods shed, used for many years as a farm store, suffered extensive fire damage in 2012 and is now demolished, and while talk of a rescue plan continues, the former station platform buildings, picturesque in their dilapidation, are in a state of near-collapse. The line opened on 28 February 1905, providing a fifty-five-minute service between Moniaive – the birthplace of the celebrated Annie Laurie – and Dumfries. Three passenger trains were timetabled each way daily, four on a Wednesday and Saturday but nothing on a Sunday. As with many other light railways, the line proved unprofitable and inevitable closure occurred in 1949.

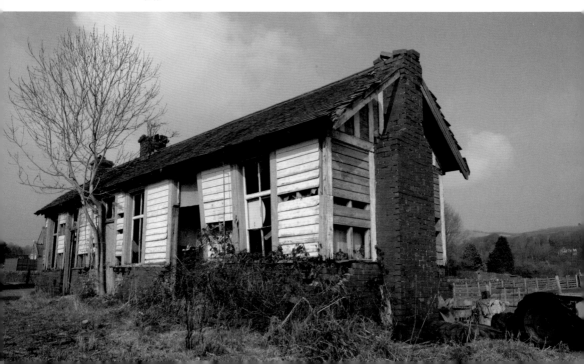

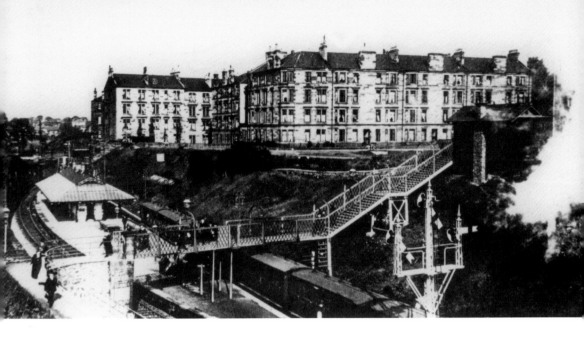

## Mount Florida Station

The station, known to generations of football supporters heading for Hampden Park, is serviced by relays of trains from Glasgow. Opened on 1 March 1886 by the Cathcart Railway Company, the island platform Mount Florida Station was constructed to service the burgeoning population of the South Side of Glasgow and was adjacent to the major football stadium Hampden Park. In fact the site of the original Hampden was abandoned as the path of the new railway cut through the football ground's western terracing. In due course the station served the second Hampden Park, later renamed Cathkin Park, which became the home of Third Lanark AC. The third Hampden Park opened in 1903 as the world's largest stadium. Appropriately the ground's original twin grandstands were designed by the celebrated railway architect James Miller.

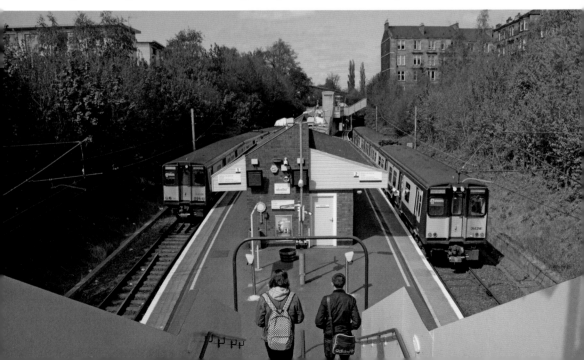

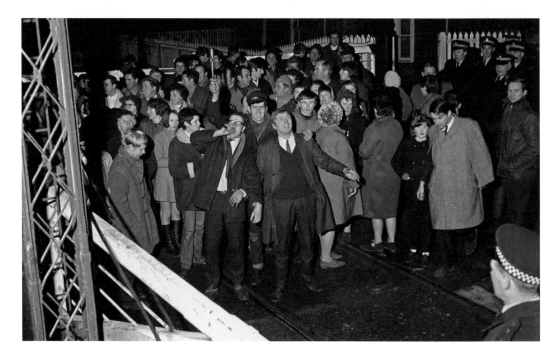

## Newcastleton Station

On a winter's night in 1969 events at the level crossing of this sleepy borders railway station made headlines and news bulletins across the country. Newcastleton Station was part of the doomed Waverley Route which, after an enquiry and spirited protest campaign, was to close on 6 January 1969. The last train through the station would be the 21.55 p.m. sleeper service from Edinburgh. The express arrived to find a Land Rover pushed across the track and protesters, led by the local minister, the Revd Brydon Maben, stood on the level crossing preventing the opening of the gates. As police led Revd Maben away a young David Steel MP, a passenger on the train, opened negotiations between the police and protestors, which resulted in an eventual climb down, the Reverend released, and the delayed sleeper continuing its journey south.

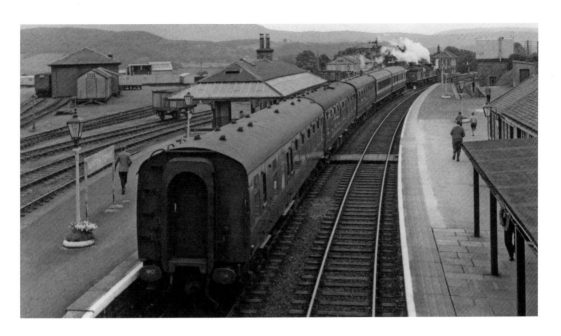

### Newton Stewart Station

Richard Hannay, the hero in John Buchan's 1915 novel *The Thirty-nine Steps*, makes good his escape north from London by train. His destination is Newton Stewart Station and, but for a number of twists in the plot, he might have made it. To achieve the journey by rail today is impossible. The railway ceases at Dumfries, the Port Line west to Newton Stewart, Stranraer and Portpatrick was a victim of the Beeching cuts in 1965. The site of Newton Stewart Station is now an industrial estate appropriately named Station Yard. Apart from an over bridge on Station Road and the former engine shed in use as an industrial unit, little evidence of the railway now remains. Today the nearest railway stations to the town are Dumfries, a distance of forty-eight miles, and Barrhill, eighteen miles.

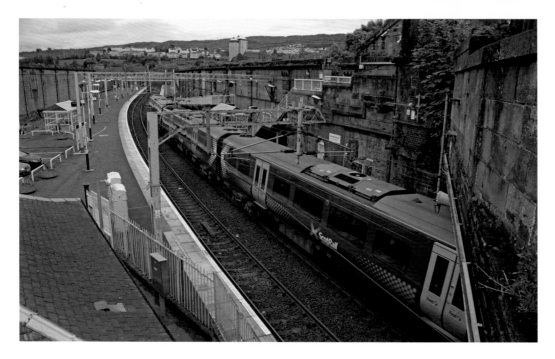

## Newton Street Tunnel

The longest bored railway tunnel in Scotland. At one mile and 351 yards long from Greenock West to Fort Matilda Stations it is shorter than the Argyll and North Clyde line tunnels under Glasgow, built using the cut-and-cover method. Opened by the CR in 1889 the tunnel was part of a £60,000 Greenock to Gourock extension and in a remarkable feat of engineering was dug under the G&SWR's Union Street tunnel. This gave the company access to the Clyde where they built a passenger pier larger than their rival's, Princes Pier. The spoil from the tunnel was used to construct Gourock's Battery Park, the site of the Admiralty's 1907 torpedo factory. In 1990 a routine survey indicated movement in the tunnel, which led to an eighteen month closure for over £2 million worth of repairs and questions at Westminster concerning the delay.

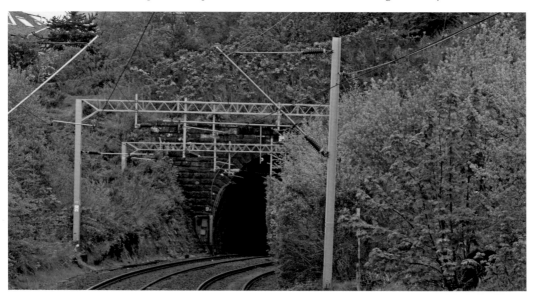

## North Berwick Branch

The NBR constructed the branch from the main line at Drem with one intention, elevating the sleepy port of North Berwick into a high-class dormitory town for Victorian Edinburgh, appealing to professional city workers with aspirations of a life by the sea. The four-and-a-half-mile line opened in 1850, failed to reach its expected targets and steam was replaced by a horse-drawn rail service, the 'Dandy Car' is preserved at the National Railway Museum, York. However, increasing holiday traffic, alongside the town's emergence as a major golf centre, produced a marked financial improvement, The 'Biarritz of the North' prospered at last! The branch survived both Beeching and Serpel reports and, although the intermediate station at Dirleton closed, the electrified line today carries a growing number of passengers to and from the remodelled North Berwick Station.

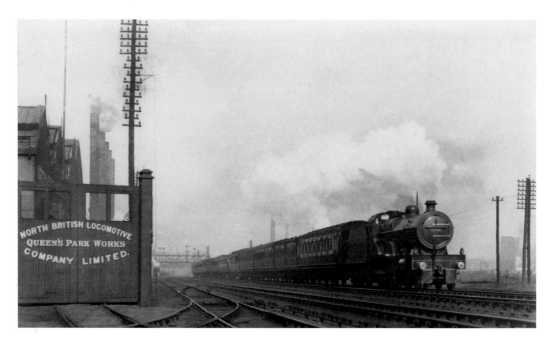

### North British Locomotive Company

'Locomotives For The World's Railways', was the proud boast of the North British Locomotive Company. Created in 1903 through an amalgamation of three Glasgow locomotive manufacturers, Sharp Stewart and Company, Neilson Reid and Company and Dubs and Company, its locomotives were built for Great Britain and the world, each one of them displaying the famous diamond work's plate. Its factories were located in Springburn and Queen's Park and it was at Springburn where, in 1909, the company opened its new headquarters building designed by James Miller. After the Second World War increasing design and workmanship problems emptied the order books and the company was liquidated in 1962. Today the category A-listed headquarters building is part of the Glasgow Kelvin College campus.

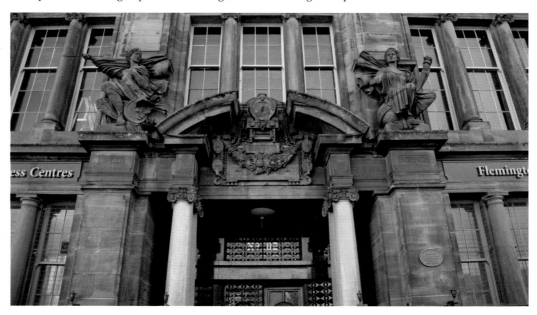

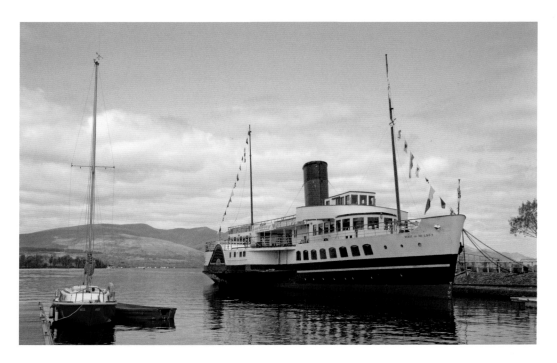

## Paddle Steamers

PS *Waverley*, the last sea-going paddle steamer in the world, is a tangible reminder of the long tradition of Glaswegians going 'doon the watter'. She was built on the Clyde in 1947 for the LNER Clyde route from Craigendoran to Arrocher. The railway companies, eager to exploit the market, invested in their own fleets of ships in competition with the existing fleets, to ensure they maximised their profits from this growing trade. *Waverley* is now in the hands of the Paddle Steamer Preservation Society and continues to ply British waters including the Clyde. By Balloch Pier on Loch Lomond and currently undergoing restoration by the Loch Lomond Steamship Company is *Maid of the Loch*, built for the British Transport Commission, she was launched in 1953 and was the last paddle steamer to be built in Britain.

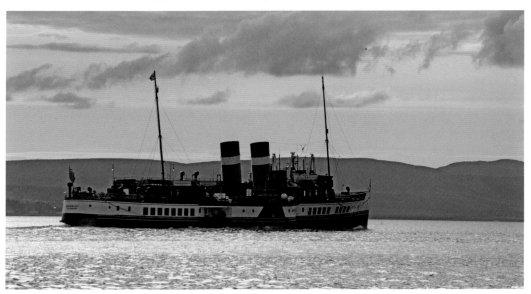

## Paisley Canal Station

In July 1865 the G&WSR acquired the Glasgow, Paisley and Ardrossan Canal for £91,000. The loss-making canal had been a part of an 1806 scheme by the Earl of Eglinton to link Glasgow with Ardrossan harbour. Unfortunately the cutting of the canal from Glasgow was abandoned at Johnston when the money ran out. The G&SWR immediately dismissed rumours that it intended to drain the canal and lay track along its length, but in 1881 an Act of Parliament gave the company the authority to do exactly what it had denied a couple of years earlier! Paisley Canal Station opened in 1885 and closed to passengers in January 1983. However seven years later, in July 1990, passenger services were resumed. By then the original station had been sold so a new station was constructed to the east.

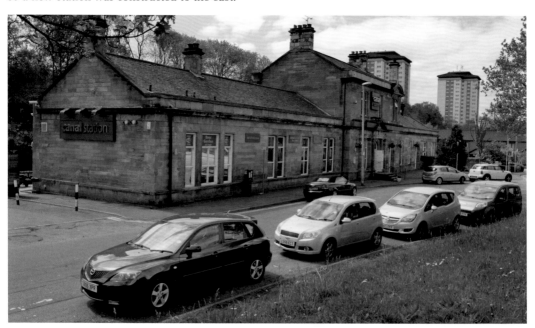

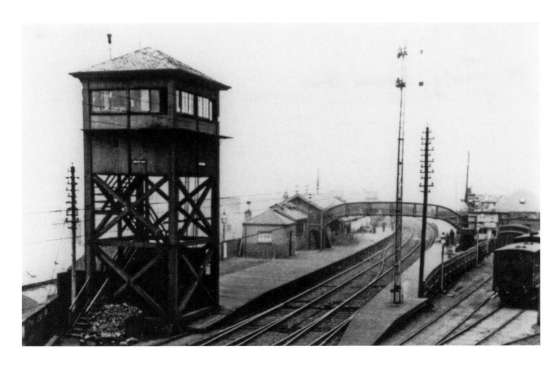

### Paisley Gilmour Street Station

The imposing main entrance of the station, built to a castellated design to match the adjacent Renfrew County Buildings and Jail, leads passengers up to the platforms at first floor level where they emerge under an immense glass canopy. Originally built as a through station on a viaduct with two platforms, later expanded to four, the category B-listed station is now the fourth busiest station in Scotland, with all the traffic going west from Glasgow passing through, the equivalent of London's Clapham Junction. The station came into being following an 1830s survey of the volume of pedestrian and canal traffic between Glasgow and Paisley, which convinced investors that a railway between the two centres would be profitable. As a result the G&PJR opened in 1840 between Glasgow Bridge Street and Paisley Gilmour Street stations.

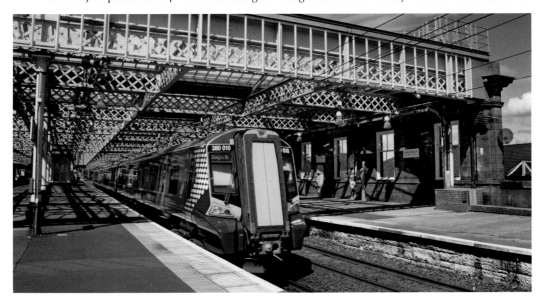

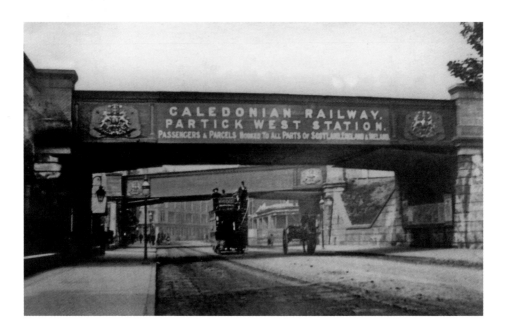

### Partick Station

The Glasgow Subway and the adjacent bus station make Partick Station one of the major transport hubs in Glasgow. The interchange dates from 1979 when the rail station joined the subway on the Merkland Street site, the bus station arriving later in 1982. The original railway station, named Partickhill, was opened by the NBR in 1887, a short distance away to the northern side of the Dumbarton Road. It closed shortly after the opening of the interchange though its platforms are still visible. The other two stations at Partick, Central and West, were victims of the Beeching cuts. Crow Road, another station that served Partick, closed earlier in 1960. Due to the district's large population of Gaelic speakers the station was one of the first to display bilingual English and Gaelic signs.

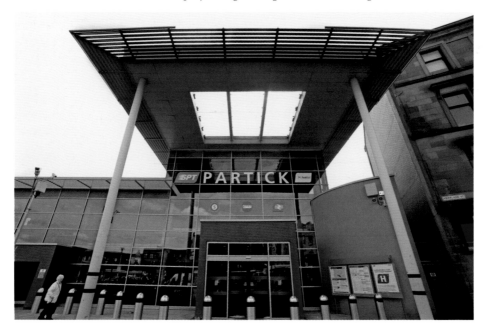

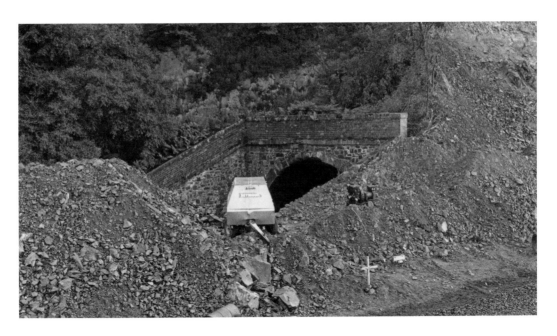

### Penmanshiel

On 17 March 1979 improvement work prior to the introduction of larger freight containers was taking place in Penmanshiel Tunnel on the ECML near Grantshouse. The tunnel had been constructed between 1845 and 1846 to a design by John Miller. Around 3.45 a.m., fifteen people were working in the tunnel when the duty works inspector noticed rock flaking away from the tunnel wall. Making his way to the site office to arrange shoring of the affected area he heard the tunnel collapse behind him. Thirteen people escaped but Gordon Turnbull and Peter Fowler were buried under the rock fall and their bodies were never recovered. A decision was made to abandon the tunnel and divert the railway. Today the southern portal is buried while on the hill above the tunnel stands a fitting memorial to the two men.

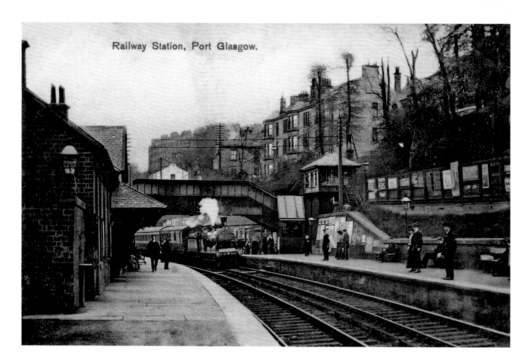

Railway Station, Port Glasgow.

### Port Glasgow Station

The innovation and enterprise of Glasgow merchants created Port Glasgow. In 1688 they laid out a town and constructed a harbour, which became the major shipping centre on the River Clyde. As Greenock expanded and the river was deepened, the port's influence declined. So it was a boost to the town's fortunes when in March 1841 the Glasgow, Paisley & Greenock Railway opened a station at the foot of Barrs Brae adjacent to the town centre. In 1865 Port Glasgow Station became an interchange when the single-track branch line to Wemyss Bay opened. This traffic was catered for with a now filled-in bay platform on the down side of the station. Today the station has been remodelled and a convenient park-and-ride facility constructed on the hill above.

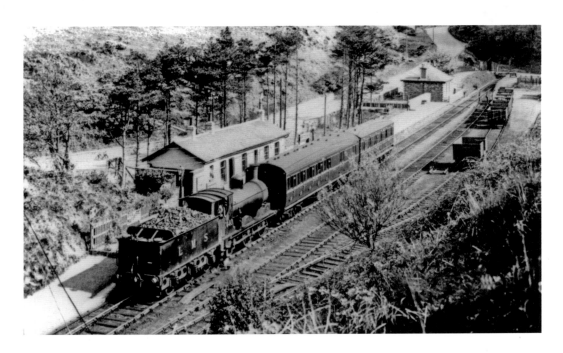

### Portpatrick

Portpatrick boasted the shortest sea crossing to Ireland but there was a problem. Though public money had been poured into the port it had been impossible to create a safe, all-weather harbour. Prevailing south-westerly winds combined with a constant rolling swell hampered the passage of cattle, troops and mail. The introduction of steam ships allowed ports further from the Irish mainland but with safer harbours to gain the advantage. So it was a town in economic decline that welcomed the opening of the station on 2 August 1862 and the harbour branch on 1 October. The harbour branch was quickly abandoned, the port's maritime traffic shifting to Stranraer's sheltered harbour. The high station as it was known carried on until closure on 6 February 1950. Today the site is a housing estate.

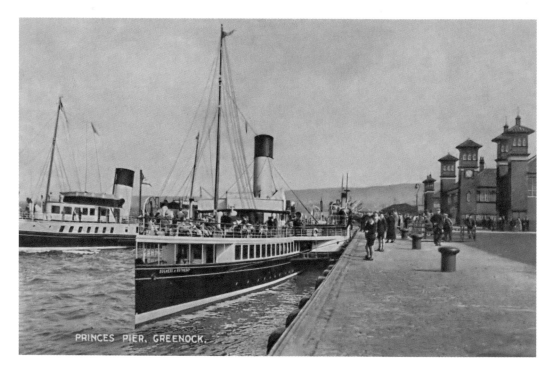

PRINCES PIER, GREENOCK.

### Princes Pier Station

Known as Greenock Albert Harbour, the station was opened in 1869 by the G&SWR. The CR had opposed the station arguing that they provided adequate cheap services to Greenock. Commercial war broke out and fares were slashed between Glasgow and Greenock. The station was renamed Princes Pier after a visit by Prince Alfred Duke of Edinburgh and was replaced by a James Miller-designed terminus in 1894 and, with its adjacent quay, was a great convenience for passengers connecting between rail and steamer. Steamer traffic continued and the boat-train service connected Glasgow St Enoch with transatlantic sailings. During the Second World War, American GIs disembarking were transported throughout Britain by rail. Only boat-train connections were running into the station when it closed to passengers in 1965. Today Greenock Ocean Terminal stands on the site.

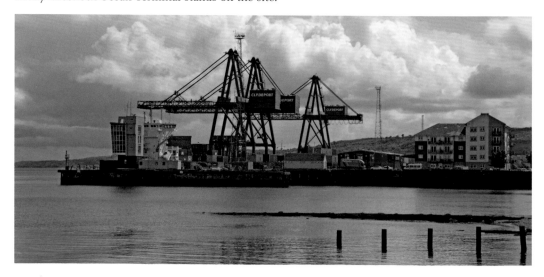

## Quintinshill

Looking down onto the WCML from this vantage point it is difficult to imagine that here, on the morning of 22 May 1915, occurred the worst catastrophe in British railway history. A troop train transporting men from Larbert to Liverpool en route to Gallipoli collided with a local passenger train that had been mistakenly given a pathway onto the main line. The crash, which ultimately included five trains, killed at least 226 and injured 246, mostly members of the Royal Scots battalion. Many were burned alive. Wooden carriages with lamps fuelled by gas and locked carriage doors made it difficult for the soldiers to escape the inferno. Two railway signalmen were subsequently jailed for their actions. A mass military grave was made for the soldiers at Rosebank Cemetery, Leith, hometown to many of the men.

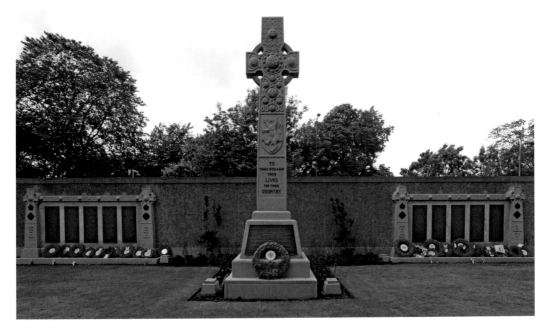

## Renfrew Wharf Station

Constructed to the 'Scotch Gauge' of four feet six inches, the railway opened on 3 April 1837. The Paisley and Renfrew Railway Company's line ran from Hamilton Street Station, Paisley, through to the Wharf Station, transporting both passengers and freight from Paisley to the Clyde steamers, in direct competition with shipping on the River Cart. Taken over by the G&SWR it remained horse-operated until it was re-gauged in 1866, when a timetabled passenger service from Glasgow St Enoch was introduced, the branch serving shipyards and factories in the vicinity of the riverbank with a substantial marshalling yard. The line closed in 1981 and today little evidence survives. The remains of a platform can be spotted in the surrounding scrubland, however encroaching housing development is likely to sweep away any visual traces of the station.

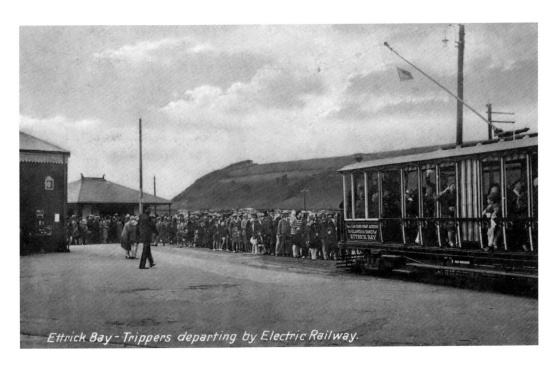

Ettrick Bay - Trippers departing by Electric Railway.

## Rothesay and Ettrick Bay Light Railway

The only Scottish island with a tramway system was Bute. The horse-drawn' four-feet-gauge track from the Rothesay Promenade to Port Bannatyne was opened in 1882. By 1905 the line had been re-gauged to three feet six inches, electrified, and a two-mile extension along a reserved right of way laid to Ettrick Bay. During the summer the tramway was busy, transporting trippers to and from the steamers sailing into Rothesay Harbour. Unfortunately, though an 8 mph speed limit was placed on the trams, it didn't prevent a six-year-old boy making a fatal dash across the track at Skeoch Wood. The line closed on 30 September 1936. Visitors now enjoy the Tramways Walk on foot, following its course between Port Bannatyne and Ettrick Bay. The Port Bannatyne tram shed survives as a bus garage.

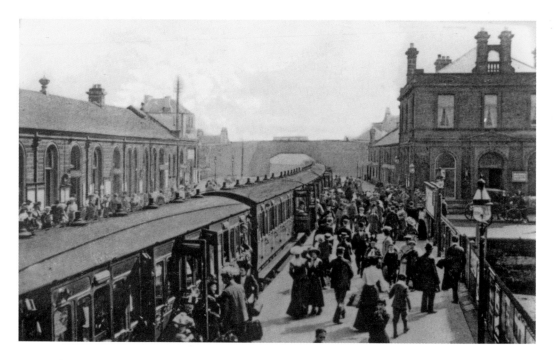

## Saltcoats Station

Bracing Saltcoats, the town's first station, was opened in 1840 by the Ardrossan Railway Company. Eighteent years later the station was relocated a short distance to the west and in 1882 the station, now in the ownership of the G&SWR, moved again to its present site. With increased railway traffic Saltcoats became a popular resort on the Firth of Clyde, as thousands of Glaswegians escaped to the town during the summer months. The category B-listed station, renamed Saltcoats Central for a while in the 1950s, was constructed with red sandstone block, with arched openings in a mock Renaissance style, and is not of the usual G&SWR design. The railway south of the station on Seaview Road is exposed to high winds and waves, making for dramatic news images and severely testing the infrastructure.

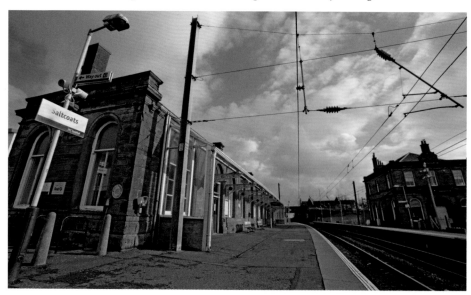

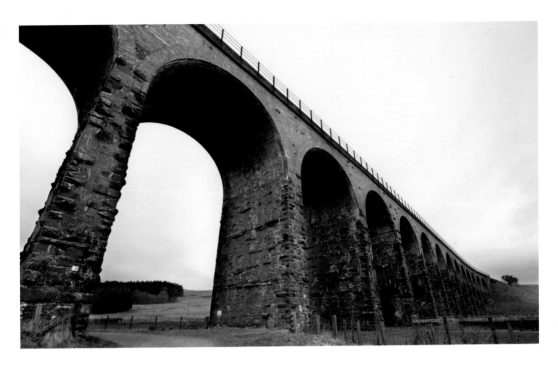

## Shankend Viaduct

The viaduct, huge and brooding, dominates the bleak moorland landscape for miles around. An impressive testimony to Victorian engineering, it is situated eight miles south of Hawick. Designed by William Jupp, it measures 200 yards long with fifteen 35 feet wide arches up to 60 feet high. Built between 1859 and 1862 by the Border Union Railway Company as part of the Waverley Route, the category B listed structure was constructed from a mixture of brick and locally quarried stone. The line closed in 1969 and, unlike the current reinstating of the line further north, it seems that this southern end of the route will never reopen due to the unproductive miles between Hawick and Carlisle. The viaduct underwent extensive repairs and waterproofing in 2007 and is now in the care of the Highways Agency Historical Railways Estate.

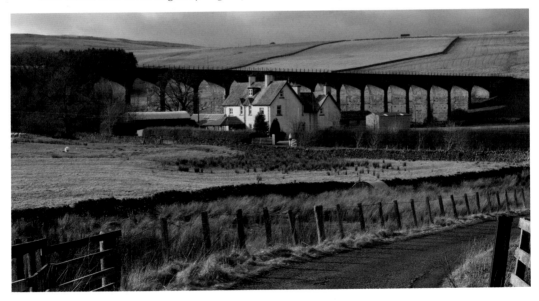

## Solway Viaduct

Opened in 1847, the Solway Junction Railway's mile-long viaduct across the Solway Firth between Annan and Bowness was built to transport Cumberland hematite to the steelworks of Lanarkshire. When ice floes demolished 45 of the viaduct's 193 piers in January 1881 traffic had almost disappeared, imported ore having destroyed the Cumbrian industry. The viaduct reopened in May 1884 but repairs were constant and it closed in 1921. Unfortunately piles broken off during the viaduct's dismantling by the LMS in 1935 consistently holed fishing boats, while stones deposited on the seabed to prevent scouring created a massive sand bank. The company was ordered to remove the obstacles. This took years to complete, as work could only be undertaken by hand during the lowest tides. Today the abutments face each other across the Firth, reminders of a failed enterprise.

### St Leonard's Bank Railway Tunnel

Thought to be the earliest public railway tunnel in Scotland, it was constructed by the Edinburgh and Dalkeith Railway Company between 1827 and 1830 to transport coal wagons under Arthur's Seat. The tunnel, 566 yards long and 20 feet wide, was excavated from volcanic rock and on an incline of 1 in 30, so the horse-drawn railway installed rope working from two stationary steam engines through the gas-lit tunnel. Steam locomotives replaced the ropeway when the NBR purchased the line in 1845. Passenger operation on the line ceased in 1847 but mineral and goods services continued until the branch closed in 1968. Today the sandstone-lined tunnel is part of the one and three-quarter miles Innocent Railway Footpath and Cycle Way, one of a number of city cycle paths converted from its disused railways.

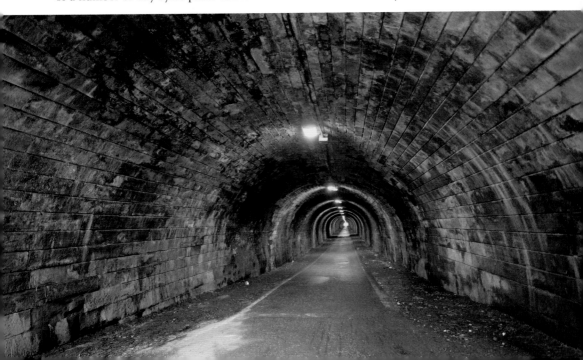

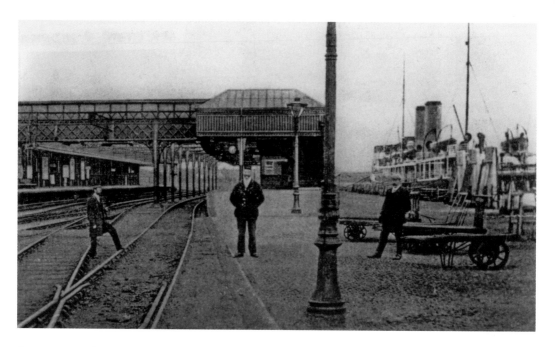

### Stranraer Station

Stranraer Station, the oldest working harbour station in the UK, stands at the end of the long line from Glasgow, once bustling with ferry passengers crossing between Scotland and Ireland. The failure of Portpatrick Harbour resulted in the transfer of Irish shipping traffic to the sheltered waters of Loch Ryan at Stranraer. The Portpatrick Railway Company constructed Stranraer Harbour Station on the pier head of Stranraer harbour, which opened on 1 October 1862. Ferry services to Ireland had started a year earlier leaving passengers the inconvenience of making their way from Stranraer Town Station (closed in 1966) to the steamers. In 2006 'Harbour' was dropped from the station's name and five years later ferry services were transferred to new facilities at Cairnryan, eight miles away on the northern side of the loch, complete with a bus link from Ayr.

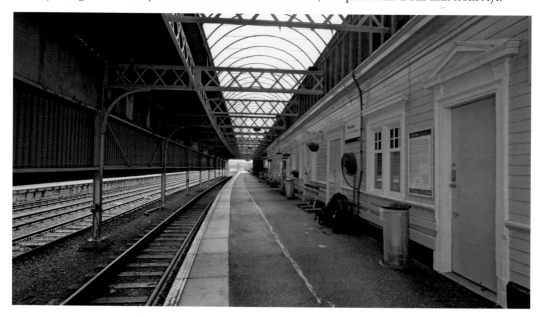

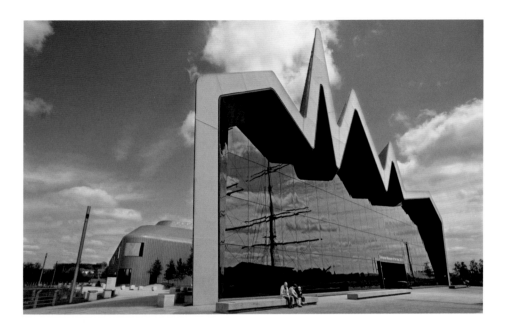

### Transport Museum

The new purpose-built Riverside Museum stands self-confidently on the banks of the Clyde, occupying the site of the old A. & J. Inglis shipyard. Riverside opened in June 2011 and was crowned European Museum of the Year two years later. It houses over 3,000 objects detailing Glasgow's transport heritage, including locomotives, ship models, trams, and all forms of road transport. Prominent is a North British locomotive manufactured at Polmadie works in 1945 for South African Railways. Repatriated in 2006, it helped raise public funding for the new museum. First established in 1964, the transport museum was housed in the disused Coplawhill tram depot, now 'Tramway' – an international centre for arts. In 1987 it relocated to the city's Kelvin Hall where it attracted more than half a million visitors a year until its closure in 2010.

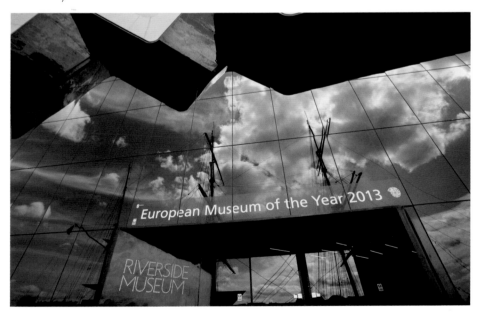

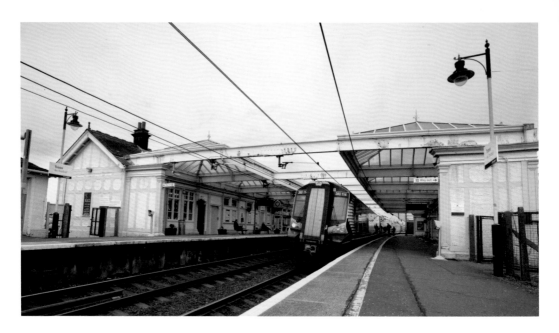

### Troon Station

Recognised as an outstanding example of railway architect James Miller's 'seaside' style, Troon Station opened to the public on 2 May 1892 and survives remarkably intact today. It replaced Troon (old) Station, located on another line to the east. The new G&SWR station served a residential town that was rapidly developing as a middle class holiday resort, complete with a number of fine golf courses. Trippers flocked to the unspoiled resorts of the Clyde coast from Glasgow and its environs and in the summer months of the 1930s the LMS ran its popular 'Evening Breather' trains, allowing city office workers the chance of a few hours on the beaches. When the Open Golf Championship was played at Troon in 2004 it was estimated that over 100,000 passengers passed through this delightful category B-listed station.

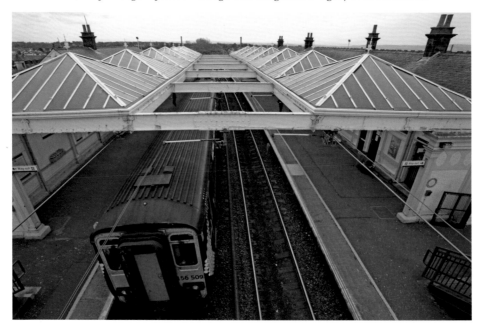

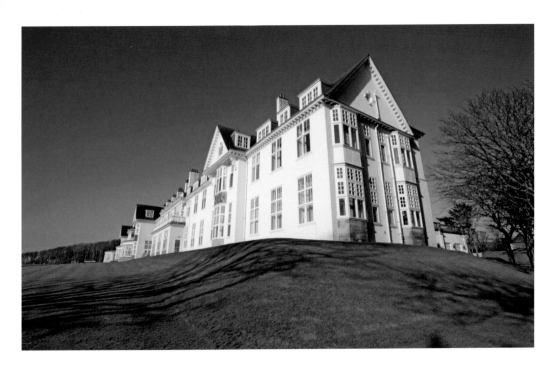

## Turnberry Hotel

In sight of Ailsa Craig on the South Ayrshire shores of the Firth of Clyde, the soft folds of the dunes with their turfy hollows are a natural location for the game of golf. It was at Turnberry that Lord Ailsa, Archibald Kennedy, collaborated with the G&SWR to establish the first purpose-planned golfing resort in Britain. The courses, along with a long and elegant hotel designed by James Miller, opened on 17 May 1906. The Maidens and Dunure Light Railway, built to provide a railway connection to the resort, constructed a station in the hotel grounds. Today the hotel and championship courses have been renamed Trump Turnberry after its new owner. The railway, of which an embankment and bridge still survive on the estate, closed in March 1942. The station site is now a hotel car park.

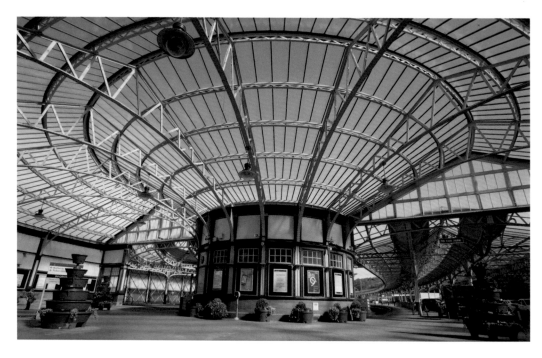

### Wemyss Bay Station

Recognised as one of the UK's finest stations, the category A-listed terminus is a delight – a masterpiece in steel and glass. The 1903 station replaced an earlier one opened in 1865. It was designed to manage the vast flow of passengers – holidaymakers and day-trippers – arriving from Glasgow. No luggage was to be carried – it went on ahead. The Glasgow and Wemyss Bay Railway was built primarily as a passenger route to service steamer traffic between Rothesay and the mainland. The CR took control of the line in 1893 and CR engineer-in-chief Donald Matheson and architect James Miller were engaged in a complete rebuild of the station and pier. Today, although passenger numbers have declined, the station survives complete with the style and grandeur demanded in the brief given to Miller and Matheson.

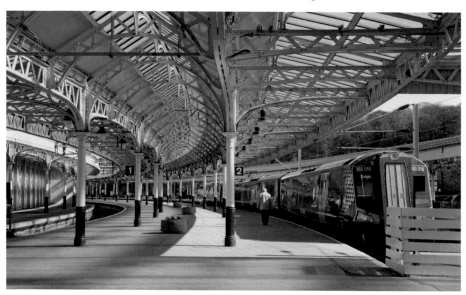

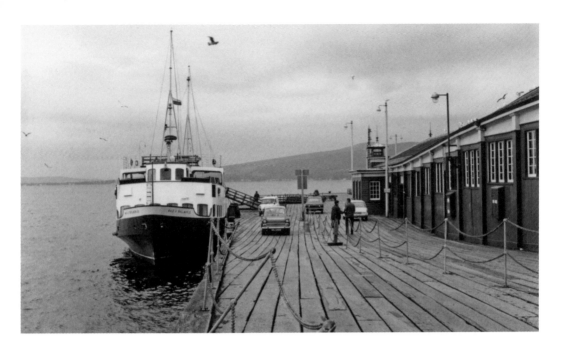

### Wemyss Bay Station Pier

Now a shadow of its former self, Wemyss Bay Pier has the honour of not only being the first but also the last railway pier on the Clyde estuary. Where once there was capacity for five berths, after shortening and a rebuild in the 1980s only CalMac's roll-on-roll-off facilities remain and long gone is the Pier Master's octagonal hut, complete with light and semaphore signals. The pier opened in May 1865 as investors realised the potential of thirty minutes sailing time to Rothesay, thus avoiding the great bend in the river suffered by steamers on route from Greenock. The vast numbers of holidaymakers has dwindled and now the pier also services commuters, shoppers and day-trippers. One can live on the beautiful Island of Bute and commute to Glasgow.

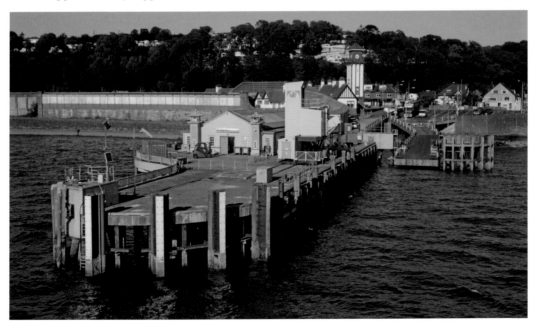

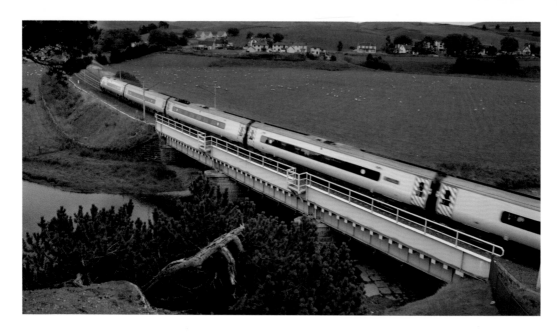

## West Coast Main Line

It is in the Clyde Valley, 800 feet above sea level, where the WCML in Scotland is at its finest as it crosses the river bridge at Crawford and follows the curve of the valley northwards. The line, built by the CR and opened in 1848, speeds passengers and freight traffic between London and Glasgow. It is a fast section of track, which fully demonstrates the tilting mechanisms of the Pendelino and Voyager sets and allows a full examination of the Class 66 and 92 hauled freight trains. Today the railway ignores Crawford village, now a sleepy backwater but once an important stop on the main road to Glasgow. It had its own station from 1891 until closure in 1965, a victim of the Beeching cuts.

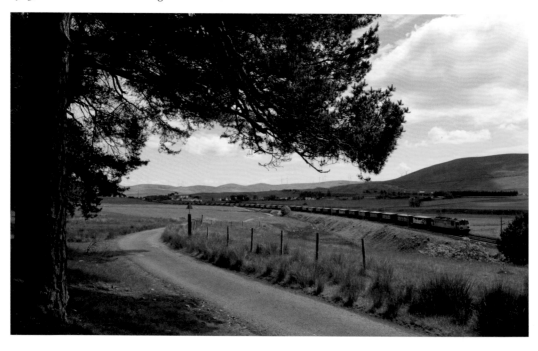

## Engineers and Architects

Some of the greatest engineers and architects were involved in the building and development of the Scottish railway network and their legacy is still visible today. Three of the most prolific exponents of their profession were John Miller, James Miller and Sir William Arrol.

John Miller was born in 1805 in Ayr, where his father was a joiner. In 1823, after working for a solicitor, he moved to Edinburgh, working in the civil engineering and surveying offices of Thomas Grainger. In 1825, after a spell at Edinburgh University and at just twenty years old, Grainger offered him a full partnership. The company was responsible for many of the great railway schemes in Scotland, including the Edinburgh and Glasgow Railway, in which Miller took the lead. Work was not confined to railways; harbour and road design was also undertaken. In 1845 the partnership was dissolved and five years later at the age of forty-five John retired. He was briefly Liberal MP for Edinburgh between 1868 and 1874 and died in Edinburgh on 8 May 1883.

The son of a Perthshire farmer, James Miller was born in Auchtergaven in 1860. After serving his apprenticeship with a Perth architect he joined the Caledonian Railways engineering offices in 1888, designing a number of stations under the supervision of engineers-in-chief, Graham and Matheson. By 1892 Miller had set up his own practice at 223 West George Street in Glasgow, gaining commissions for hospitals, factories and public buildings on both sides of the border, while continuing his railway work. This included designs for the West Highland Line stations, Turnberry Hotel and the magnificent Wemyss Bay Station. James retired in 1940 at the age of eighty, dying at his Stirling home on 28 November 1947.

William Arrol was born in 1839 in Houston, Renfrewshire, the son of a spinner. At the age of thirteen he worked as an apprentice blacksmith while studying mechanics and hydraulics at night school. In 1872, after learning his trade with a Glasgow bridge-building company, he established the Dalmarnock Iron Works in the city. Breakthrough came in 1878 when he was awarded the contract for the Caledonian Railway Bridge across the Clyde, and in 1882 the replacement Tay Bridge, completed in 1887. He also gained the contract for the Forth Bridge, which opened in 1890, the same year that he was awarded a knighthood. His company name was changed to Sir William Arrol and Co. to celebrate this. The company went on to build across the world, including Tower Bridge in London and the Nile Bridge in Egypt. Sir William served as a Liberal MP for South Ayrshire between 1895 and 1906 and died at his Seafield estate near Ayr on 20 February 1913.

# Acknowledgements

The authors would like to thank the following for the use of their photographs:

John Goss Newcastleton Station, page 68.

Tony Harden, from his collection of photographs, Fort Matilda Station, page 31.

Very special thanks must go to Mike Blakemore of Pendragon Publishing for the use of images from John Edgington's and other Pendragon collections.

Pages: 7, 9, 12, 16, 19, 21, 27, 29, 30, 36, 37, 41, 43, 45, 48, 49, 50, 51, 54, 56, 62, 63, 65, 66, 67, 68, 72, 75, 76, 77, 79, 82, 84, 88, 93.

Also thanks to:

Theresa Gault, Sponsorship and Events Manager, Abellio Scotrail.

Finally to John Yellowlees, External Relations Manager at Abellio Scotrail, for his advice, enthusiasm and friendship.

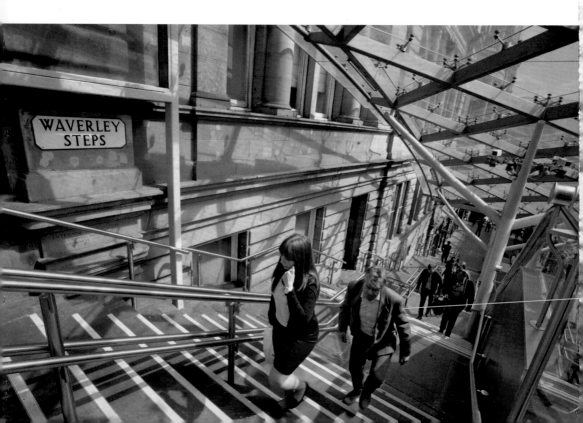